IMAGES
of America

THE HOUSE OF THE
SEVEN GABLES

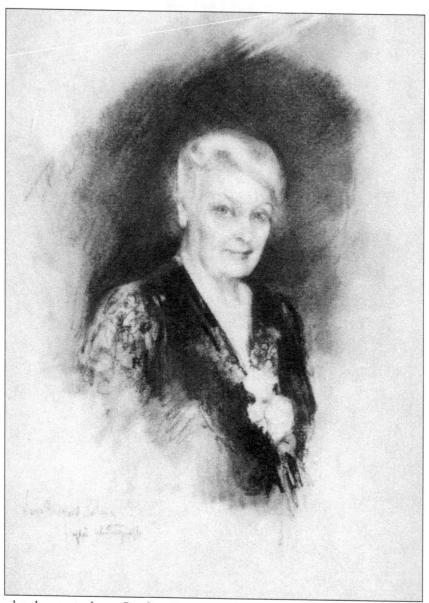

This undated portrait shows Caroline Emmerton (1866–1942), who rescued and restored the Turner-Ingersoll Mansion between 1909 and 1910. In 1910, she opened the House of the Seven Gables as a historic house museum to raise money for a settlement house. During her life, she worked on behalf of dozens of nonprofits and was personally involved at the House of the Seven Gables until her death in 1942. (Courtesy House of the Seven Gables Settlement Association.)

ON THE COVER: This photograph of the House of the Seven Gables was taken between 1910 and 1911, immediately after its restoration. The house has stood near Salem Harbor on Turner Street since its construction in 1668. It was purchased by a local philanthropist, Caroline Emmerton, and turned into a historic house museum to raise money for a settlement house that served the local immigrant community. (Courtesy Library of Congress, Prints & Photographs Division, Detroit Publishing Company Collection, LC-DIG-det-4a24964.)

IMAGES
of America

THE HOUSE OF THE SEVEN GABLES

Ryan Conary, David Moffat,
and Everett Philbrook
for the House of the Seven Gables
Settlement Association

ARCADIA
PUBLISHING

Published by Arcadia Publishing
Charleston, South Carolina

Library of Congress Control Number: 2016962506

For all general information, please contact Arcadia Publishing:
Telephone 843-853-2070
Fax 843-853-0044
E-mail sales@arcadiapublishing.com
For customer service and orders:
Toll-Free 1-888-313-2665

Visit us on the Internet at www.arcadiapublishing.com

*This volume is respectfully dedicated to Caroline Emmerton, whose
vision of historic preservation and social services improved many lives.*

CONTENTS

ACKNOWLEDGMENTS

The authors wish to thank the Phillips Library at the Peabody Essex Museum, Historic New England, the Boston Public Library, the Library of Congress, and the staff of the House of the Seven Gables. Unless otherwise noted, images are from the archives of the House of the Seven Gables Settlement Association.

INTRODUCTION

Few American houses have attained the reputation or the mystique of the House of the Seven Gables. Both hard work and serendipity have shaped the property across the generations.

In 1668, the newly wed John and Elizabeth Turner established their home. They were among the second generation of settlers in the Massachusetts Bay Colony. By then, Salem was already a well-established and prosperous seaport. John Turner (1644–1680) made his living as a mariner and a merchant.

The home began as a hall-and-parlor-style house, which was typical for the merchant class who could afford fair and spacious homes. The first and second floors consisted of two large rooms, with the first floor containing a parlor for entertaining guests and a hall that served as the center of family life. The house's rough beams and meandering layout survive from its earliest age. Along with swaths of original plaster, boards, and brick, these make the house of keen interest to antiquarians and architectural historians.

The Turners' son John Turner II (1671–1742) ascended to ownership of the house in 1692, simultaneously to the Salem Witch Trials, which brought lasting notoriety to his town. His own part in the drama was slight, and his focus became the upkeep and expansion of his inheritance. John Turner II refurbished his parents' home, adding refined Georgian-style paneling early in the 18th century, which still decorates the house today.

John Turner III (1709–1786), who owned the property for 40 years but who seems to have left no lasting mark on its structure, sold it at auction in 1782 near the end of the American Revolution and died four years later in greatly diminished circumstances.

The new owner, the captain and privateer Samuel Ingersoll (1744–1804), found the house old-fashioned for the booming port of Salem, which in the era of his ownership expanded its trade across the globe. Ingersoll made improvements to the structure, removing the facade gables and bringing the house in line with the Federal style of new neighboring houses.

In 1804, at the age of 60, Captain Ingersoll and his eldest son died at sea of fever, far from his family's residence. His widow, Susanna Hathorne Ingersoll (1749–1811), owned the property until her death in 1811. In a grim honor, their daughter Susanna inherited the property as the only surviving child of six. With the help of her minister, the Reverend William Bentley of Salem's East Church, Susanna Ingersoll (1784–1858) held her ground against relatives who wanted to prevent her from inheriting the home. In Bentley's own words, Susanna was "beset by the Col's family with the ferocity of tigers." Meanwhile, Susanna described the house of painful memories as "her prison."

Susanna inherited the house of her birth in 1811 and by her death in 1858, she became its longest-term inhabitant—with a tenure of 74 years. In those years, she never married and instead devoted her time to buying and selling real estate and providing mortgages for properties across Salem and Danvers. In the early 1830s, she became a benefactor to Horace Connolly, of Salem, then a student at Yale College, and around the same time began welcoming her cousin Nathaniel Hawthorne (1804–1864) into her spacious home.

Nathaniel Hawthorne was born a half mile away in the same waterfront neighborhood in 1804. His father died of fever at sea when Hawthorne was only three years old, and his mother moved him and his two sisters to her family's home nearby. In 1825, he graduated Bowdoin College and in 1828, he anonymously published his first novel, *Fanshawe*. A fateful visit to Susanna's home in 1840 inspired him to write *The House of the Seven Gables*, published in 1851. By then, Hawthorne's place as a genius of American letters had been established with his volumes of short stories (*Twice-Told Tales* volumes 1 and 2 in 1837 and 1842 and *Mosses from an Old Manse* in 1846) and his best-selling novel *The Scarlet Letter* in 1850.

Hawthorne's novel recasts the Turner-Ingersoll Mansion as the House of the Seven Gables, "a rusty wooden house" whose decline mirrors the moral failings of its inhabitants and their society. "The aspect of the venerable mansion," Hawthorne writes in the novel's opening, "has always affected me like a human countenance, bearing the traces not merely of outward storm and sunshine, but expressive, also, of the long lapse of mortal life, and accompanying vicissitudes that have passed within."

By mapping a fictional past onto his cousin's home, Hawthorne created an interplay between the structure and his text, which still enriches the old house. When Susanna died in 1858, the house was inherited by Horace Connolly (1808–1894), who owned the home for a little more than two decades and who made his own changes to the structure. It was in this period that the prominence of Hawthorne's novel brought fame to the house. In his 1880 *Visitor's Guide to Salem*, Thomas Hunt Franklin notes that Hawthorne identified no specific house as the inspiration for the novel but that "a house on Turner Street is quite often referred to as the "House of Seven Gables.'"

Connolly lost the house in 1879, and for four years, it was owned by a quick succession of absentee owners from Vermont. In 1883, the Upton family saved the house from an uncertain fate and made it their family home for 25 years. They saw the home enter the 20th century and were the last inhabitants to own the property. Henry Orlando Upton (1839–1919), the father of the family, was a music and dance teacher. So many tourists began to visit the house that the Uptons began to charge admission to see the inside.

In the brief time between Horace Connolly and the Upton ownership, a young woman named Caroline Emmerton (1866–1942) visited the property under the supervision of her aunt. She delighted at its antique features and remembered her experience in 1908 when the Upton family placed the home for sale.

A philanthropist, Emmerton had just established a settlement house, or a community center, for immigrant families in the Seaman's Bethel, at the foot of Turner Street, when she purchased the Turner-Ingersoll Mansion and transformed it into a public attraction to raise money for the charity. Emmerton downplayed the effort of a yearlong professional restoration between 1909 and 1910, saying simply "that combining a show house with a settlement was no simple matter." For the restoration, she acquired the services of Joseph Everett Chandler, an architectural historian familiar with New England's earliest homes who had recently completed a controversial restoration of the Paul Revere House in Boston.

In 1911, another ancient Salem house, the Hooper-Hathaway House from 1682, was saved from demolition and moved across town to the campus of the newly opened museum. The Retire Beckett House, dating to 1655, was added to the property in 1924 in conjunction with the addition of Colonial Revival gardens. In 1958, the Nathaniel Hawthorne Birthplace, a Georgian structure from 1750, was relocated to sit near to the author's literary shrine.

Emmerton's unique dual mission of preserving historic architecture and providing social services continues to the present day, as the House of the Seven Gables Settlement Association preserves seven historic structures and assists the local immigrant community through programming and educational efforts.

One

HALFWAY DOWN
A BY STREET

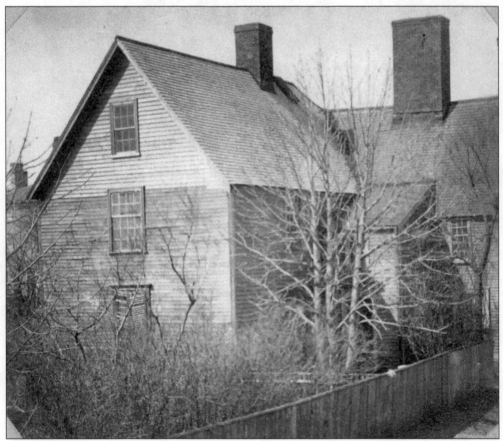

This is the earliest known photograph of the Turner-Ingersoll Mansion, also known as the House of the Seven Gables. The photograph was taken by Joshua W. or John S. Moulton, between 1857 and 1860, and shows the house as it appeared shortly after Horace Connolly came into possession of it. He added the heavy eaves, new wood clapboards to the gable of the south ell, and had the roof reshingled. (Courtesy Phillips Library, Peabody Essex Museum.)

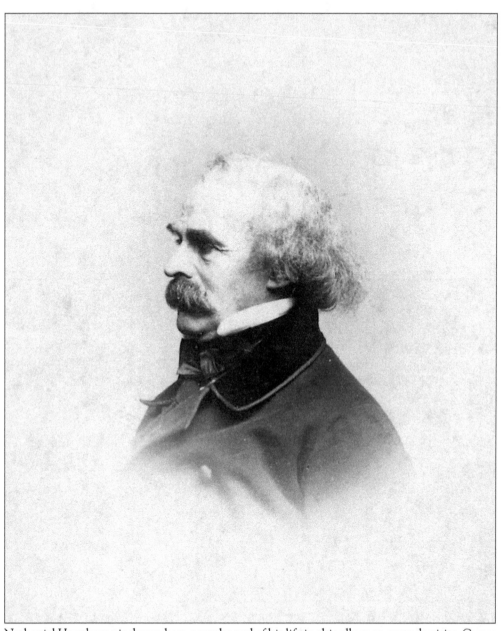

Nathaniel Hawthorne is shown here near the end of his life in this albumen carte de visite. Cartes de visite were used as calling cards, primarily from 1859 to the 1870s, and those of famous figures were collected. The photograph was taken between 1861 and 1864 by James Wallace Black, a pioneering photographer who had a studio at 173 Washington Street in Boston. In the same time period, Black also produced a portrait of Hawthorne reading and a triple portrait of Hawthorne with his publishers, William Ticknor and James Fields. Ticknor and Fields published *The House of the Seven Gables* in 1851, and within a year, it entered its fourth printing. The novel has been considered a classic and an integral part of American literature since its publication. The later novelist and critic Henry James describes the novel in his 1879 study of Hawthorne as "a rich, delightful, imaginative work, larger and more various than its companions, and full of all sorts of deep intentions, of interwoven threads of suggestion."

Susanna Ingersoll lived in the House of the Seven Gables longer than any other resident. In the course of her life, she maintained the property and purchased other real estate around Salem. The fame of her home comes from her association with her cousin Nathaniel Hawthorne, who immortalized it in *The House of the Seven Gables*. This portrait depicts Susanna at a young age, though its exact date is unknown.

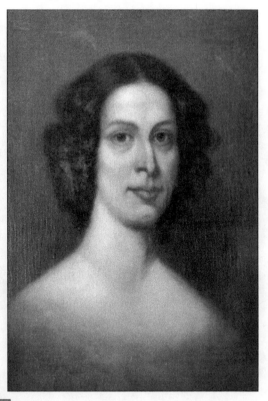

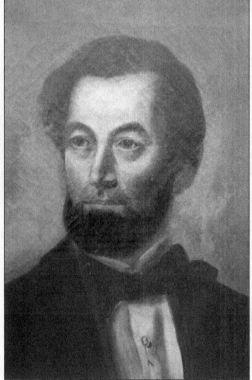

Horace Lorenzo Connolly had a mysterious early life. Susanna Ingersoll paid for his education. When she died in 1858, she left the House of the Seven Gables to Connolly, who took her last name. Connolly and Nathaniel Hawthorne, though once friends, had a disagreement and a falling out. The house was repossessed in 1879 and stood empty for four years. This portrait is believed to be of Horace Connolly, but its date is unknown.

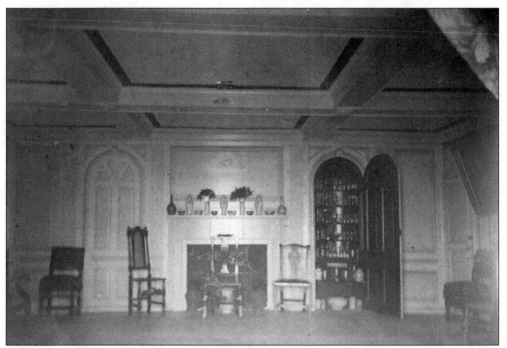

This photograph is believed to be the earliest interior view of the House of the Seven Gables, taken during Horace Connolly's ownership about 1870. The wall features the detailed paneling added in the early 18th century. The later mantel was removed during restoration. The chairs are a progression of American furniture history. The Georgian cupboard displays a collection of liquor bottles. The ceiling also shows decorative crossbeams placed perpendicular to the original 1676 beams. (Courtesy Phillips Library, Peabody Essex Museum, "54 Turner Street. Turner House Interior," filed photographs, Turner Street (1-54) House of Seven Gables.)

This photograph shows a springtime view of the property during the ownership of Horace Connolly. The windows are decorated with hooded brackets, and the front entrance of the house has been improved with a boardwalk. In the gardens, there are urns and a hollow stump used as a planter. The house at left with a mansard roof later served as a bed-and-breakfast until it burned down in 1966. (Courtesy Phillips Library, Peabody Essex Museum.)

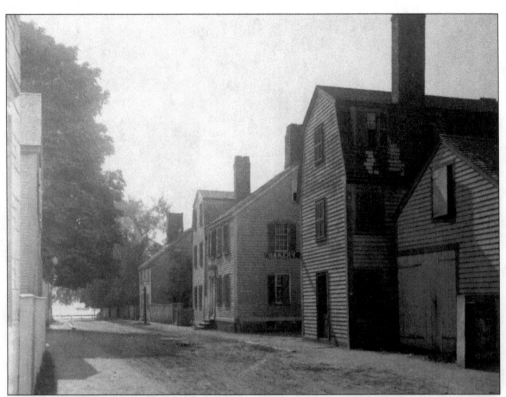

This early view of Turner Street leading
to the House of the Seven Gables shows a
diversity of wooden houses, of which only
the gambrel-roofed house in the foreground
survives. The street is unpaved and lacks
a sidewalk for much of its length. The
house at 45 Turner Street displays a sign
indicating that it is a bakery. (Courtesy
Phillips Library, Peabody Essex Museum.)

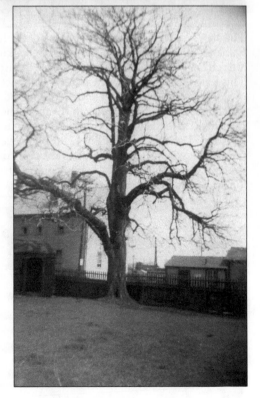

The picturesque horse chestnut tree seen here
on the lawn is associated with the "Pyncheon
Elm" in Nathaniel Hawthorne's novel. To the
left of the tree is "Clifford's summer house,"
built by Caroline Emmerton. The house at
right, across the street, is the Primm House,
built around 1891 by William G. Remon,
which is today owned by the House of the
Seven Gables. The tree no longer stands.

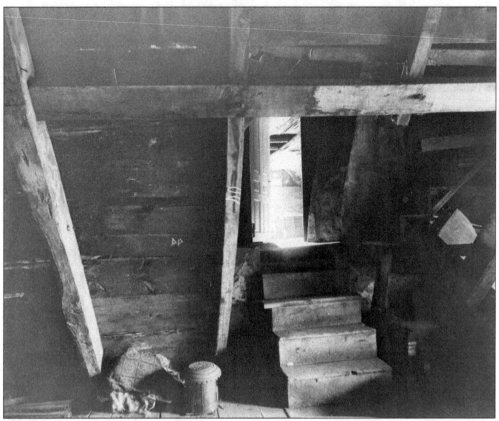

The above image is an 1892 photograph of the house's attic by Salem architectural photographer Frank Cousins. This view is facing south, looking from the attic of the 1668 house to a finished attic chamber in the 1676 addition. Visible is the postmedieval wooden frame, joined with trunnels. This feature survives from the house's construction, and the attic is one of the least altered parts of the house. The image below is an undated photograph of the attic focusing on the stairs, which lead to a scuttle window in the roof. The chimney for the 1676 addition is plastered over. In an 1840 letter, Hawthorne describes a visit to the house and an exploration of the attic where he could clearly see the outlines of the removed gables. This is regarded as the genesis for the novel. (Above, courtesy Phillips Library, Peabody Essex Museum; below, courtesy Phillips Library, Peabody Essex Museum, "54 Turner Street. Attic in House of Seven Gables," filed photographs, Turner Street (1-54) House of Seven Gables.)

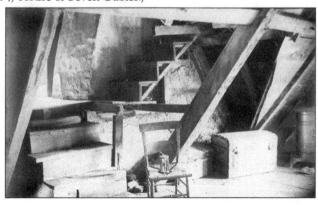

14

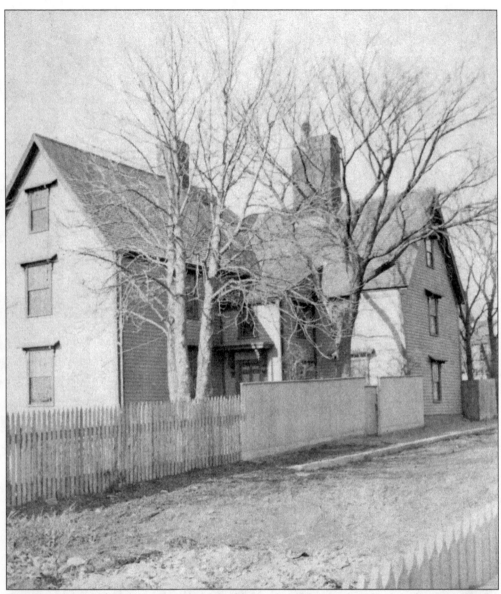

Another of the earliest known views of the house, this photograph was taken from the bottom of Turner Street around 1880. The roof retains the steep pitch of its initial construction over two centuries before. Visible on the east portion of the house (at right) is the original 1668 chimney stack. Horace Connolly replaced the original 17th-century porch with the one seen here, with a sloping roof. Caroline Emmerton later removed Connolly's porch and added one of a more 17th-century style. Emmerton writes about the property in her book *The Chronicles of Three Old Houses*: "The porch that was on the house when I bought it was a flimsy modern affair built by Horace . . . and I had been persuaded in taking it down." As for Connolly's motivations, Emmerton surmised, "He was no doubt, very proud of the house, identifying it with the story and himself with Clifford." (Courtesy Phillips Library, Peabody Essex Museum.)

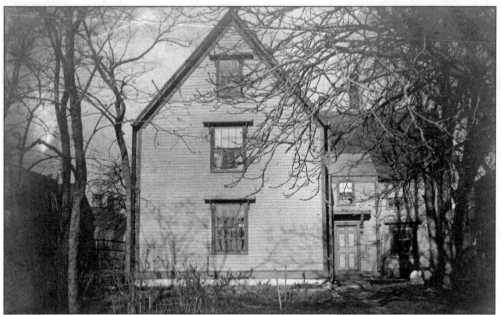

This picture was taken around 1890 during the Upton ownership. The original chimney was removed by Henry Upton and was replaced with the spindle stack seen here, which served the coal stoves in the house. The boardwalk has been shortened, and the fences and urns in the garden have been removed. A horseshoe can be seen hanging above the front door. (Courtesy Phillips Library, Peabody Essex Museum.)

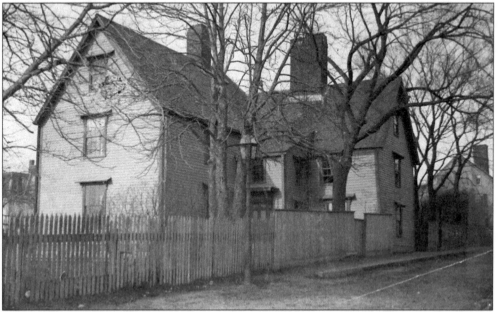

The number of early photographs of the House of the Seven Gables serves as a testament to public interest in the house in the decades following publication of Nathaniel Hawthorne's novel. This view of the house greeted sightseers who walked to the bottom of Turner Street to find the literary landmark. (Courtesy Phillips Library, Peabody Essex Museum, "54 Turner Street. House of Seven Gables," filed photographs, Turner St. (1-54) House of Seven Gables.)

Two

THE UPTON FAMILY

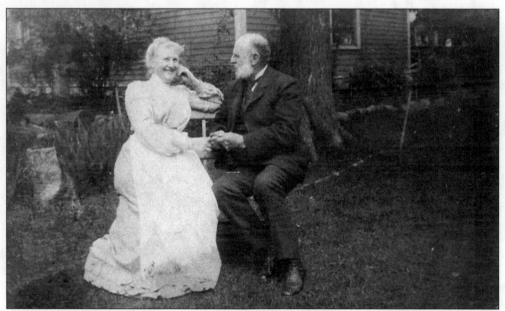

Elizabeth and Henry Upton sit together in the gardens of the House of the Seven Gables in 1904, later in their ownership of the historic structure. The couple and their family were the last residents of the house before it was acquired by Caroline Emmerton. Henry Upton, ever the romantic, lovingly clasps his wife's hand.

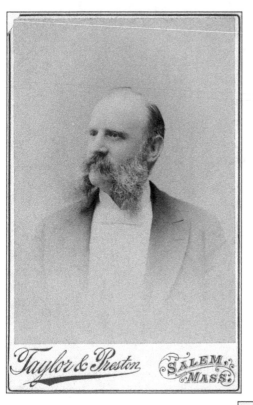

Henry Orlando Upton, seen here in a posed photograph from Taylor and Preston, was born in Salem in 1839. His father, Eben, was a musician and Henry followed into the family profession. Henry moved frequently before settling down in the House of the Seven Gables. His interest saved the house from another prospective buyer who wanted to either transform the property into a tenement or demolish it.

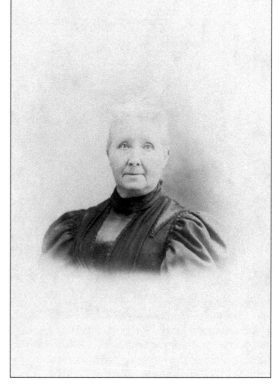

Elizabeth A. Upton, the wife of Henry Upton, was the actual purchaser of the House of the Seven Gables in 1883. Her father, James S. Cate, was a laborer who lived nearby on English Street in the 1840s and 1850s. Elizabeth and her family lived in the house for 25 years. She passed away the year after they moved from Turner Street to their new residence on Columbus Square.

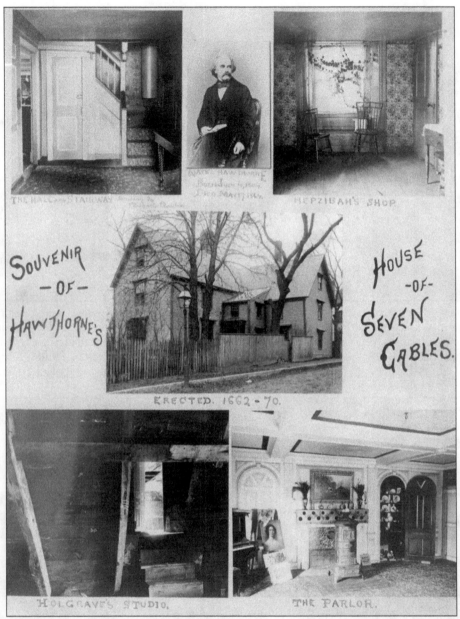

The images in the collage are labeled: THE HALL AND STAIRWAY, NATH'L HAWTHORNE Born June 4, 1804 Died May 19, 1864, HEPZIBAH'S SHOP, SOUVENIR -OF- HAWTHORNE'S, HOUSE -OF- SEVEN GABLES., ERECTED. 1662-70., HOLGRAVE'S STUDIO., THE PARLOR.

Titled *Souvenir of Hawthorne's House of Seven Gables*, this collage was assembled by Frank Cousins in 1892 as the first image of the house available for sale. It was created to meet growing interest in the home. The construction date of the house was believed at the time to be between 1662 and 1670, due to the date on an iron fireback found within the house. Images of the rooms as the Uptons furnished them are labeled with the names of rooms from Hawthorne's novel. The kitchen is identified as "Hepzibah's Cent Shop" and the great chamber garret as "Holgrave's Studio." A photograph of Nathaniel Hawthorne is included in the collage to emphasize the house's association with the famous man of letters. Though the link between the fictional house in Hawthorne's work and the Turner-Ingersoll Mansion was not invented by or first spread by the Upton family, they widely publicized it and contributed greatly to the house's fame. (Courtesy Phillips Library, Peabody Essex Museum.)

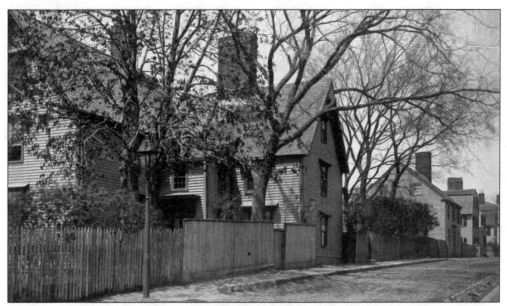

This photograph, taken in 1884 of the Turner Street side of the house, shows it in relation to the rest of Turner Street. The house is separated from the street by three mismatching sections of fence. Behind the house are seen the tall lilac bushes, which mesmerized a young Caroline Emmerton when she visited shortly before the Uptons purchased it. (Courtesy Phillips Library, Peabody Essex Museum, "54 Turner Street. House of Seven Gables. Peabody about 1884," filed photographs, Turner St. (1-54) House of Seven Gables, 18,877.)

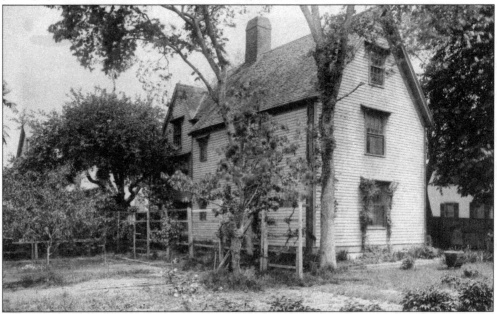

This is the earliest known photograph that shows the western side of the house. The 1676 section of the house projects farther west than the 1668 house, and visible at far left of the newer section are two small windows built to illuminate closets. These were removed by Caroline Emmerton. The Uptons' garden features plantings, trellises, an apple tree, peonies, and vines trailing up the side of the house.

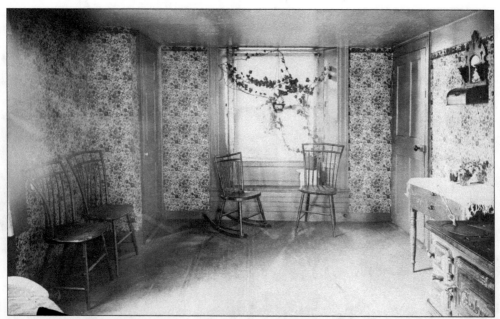

An interior shot of the 1668 portion of the house, this 1892 photograph by Frank Cousins shows the kitchen as it was used by the Upton family. A modern iron stove sits in front of the original kitchen fireplace. A closet has been built into the corner of the room, though an original 18th-century window seat remains. The kitchen is furnished with Windsor chairs and bold floral wallpaper. (Courtesy Phillips Library, Peabody Essex Museum.)

The great chamber garret of the 1676 addition shows that it was originally lathed and plastered as a finished room. Here, Nathaniel Hawthorne would have clearly seen the outline of the removed gables. In the Upton period, the room appears to be a storage space. The plaster of the ceiling is in a dilapidated state, revealing the original joists. Eben Albert Upton has left his initials on the wall.

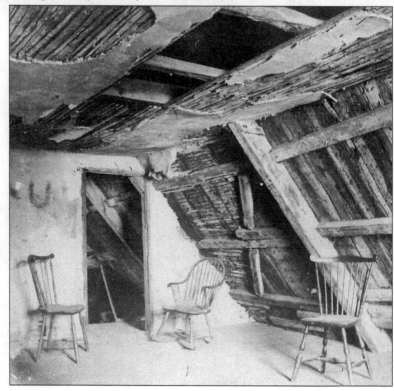

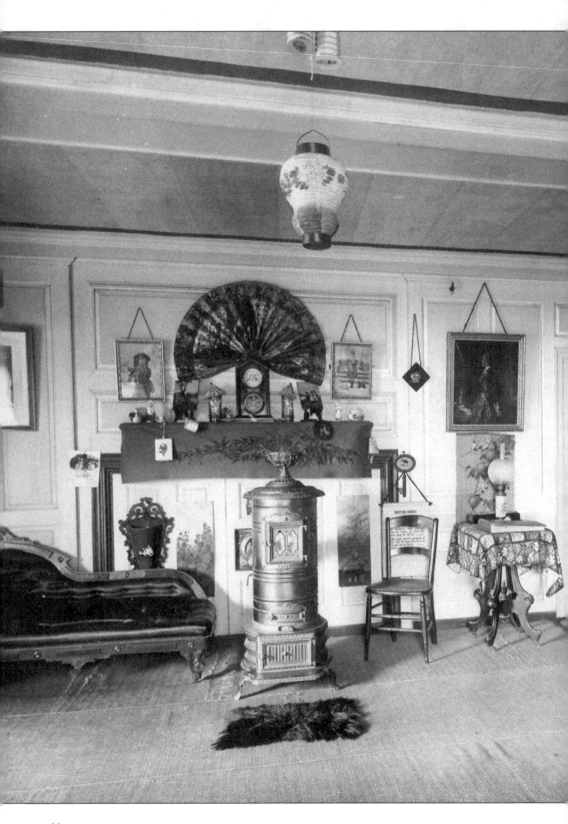

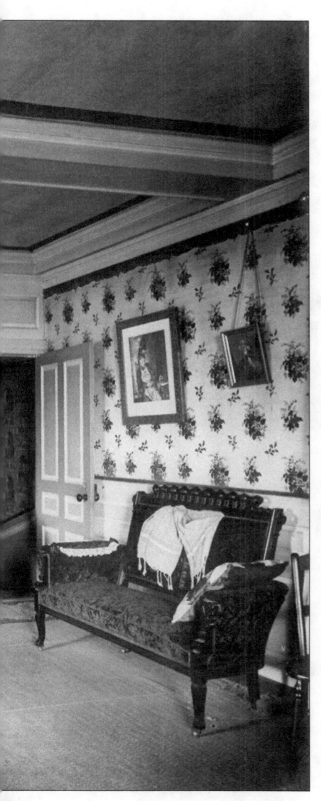

This view of the so-called great chamber of the Turner era shows the house during the Upton ownership. Located in the 1676 addition, the room features higher ceilings and is more spacious than the older rooms of the house. The floor covering is of rush matting. The Uptons' Victorian style of decoration is apparent in the furnishing of the room. A Chinese paper lantern hangs from one of the summer beams. The room features a stylish chaise lounge and love seat and an applied mantle with a cloth covering. Note the profusion of objets d'art, including a scroll of "Christian Conduct" suspended from an oversized key, the figurines on the mantel, the paintings of domestic scenes, and the Asian fans. The room is heated at the time with a large coal-burning stove, while the older fireplace has been shuttered off. (Courtesy Phillips Library, Peabody Essex Museum.)

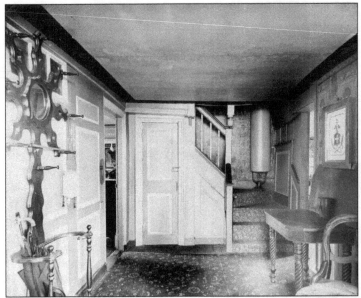

This 1892 Frank Cousins photograph of the entrance of the house shows how visitors would have first seen the interior. The staircase is carpeted, and a hot water heater sits partway up the steps. Behind the hall tree is a small window added to illuminate a closet behind. The door to the left leads to what is today the dining room, while at right hangs a framed Upton family crest. (Courtesy Phillips Library, Peabody Essex Museum.)

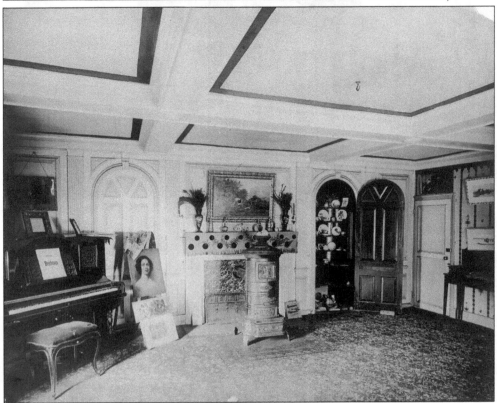

Eighteenth-century paneling and Victorian finery are both visible in this 1892 Frank Cousins photograph of the parlor. The shell-backed cupboard, which held liquor for Horace Connolly, has been replaced with a respectable china collection. The original beams are intersected by later faux-paneled beams framed with black edges to draw attention to the ceiling. By the fireplace, the portrait of Susanna Ingersoll sits unframed before its restoration by Caroline Emmerton.

This photograph focuses on a window seat adorned with lace curtains. The view out the window shows a fence built after the Uptons sold a portion of the front lawn of the home. The "Pyncheon Elm" can be seen on the other side of the fence. Every decorative feature visible in this picture is floral: the wall-to-wall carpet, the cushion and pillows, the curtains, the wallpaper, and the fancy chairs.

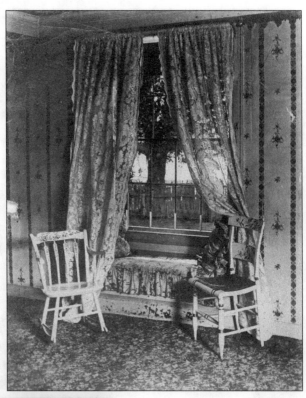

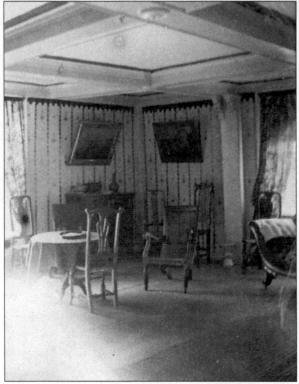

This interior view of the southwest corner of the parlor during the Uptons' residency shows their eclectic mix of chairs. Represented are chairs in the Cromwellian, William and Mary, Queen Anne, Chippendale, and Victorian styles. Added to each of the room's support posts are pairs of decorative brackets. The paintings hang forward from the wall. (Courtesy Phillips Library, Peabody Essex Museum.)

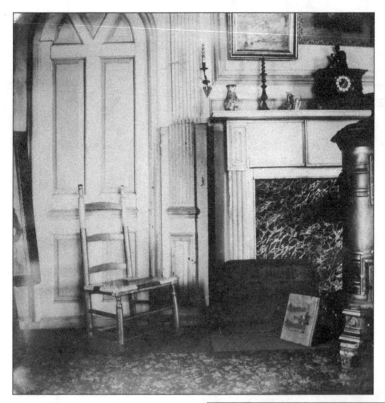

Apparent here are two features of the Georgian paneling added by John Turner II: a faux door added to balance with the cupboard door on the other side of the fireplace and a closet hidden in the pilaster. At Christmastime, the Upton family had Santa Claus emerge from the hidden door. The cast-iron fireback dates to 1662 and remains one of the longest-tenured items in the house.

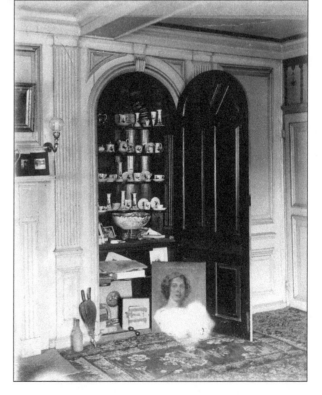

The open cupboard door reveals a 42-piece set of china hand-painted by Ida Upton Paine, featuring "The Salem Witch" on a broomstick. Paine sold painted china as one of the earliest known souvenirs of Salem. Other clutter in the cupboard includes Henry Upton's sheet music of *The House of the Seven Gables*, as well as a print of Nathaniel Hawthorne. The portrait of Susanna Ingersoll leans against the door.

In this c. 1901 photograph, four women pose on the lawn with croquet mallets. They are, from left to right, Mary Johnson, Helen Arey, Annie Paine, and Lillian Arey. Helen and Lillian were the daughters of Sarah "Sadie" Upton Arey and granddaughters of Henry and Elizabeth Upton. The area in front of the house, once a hub of maritime commerce, has become a place of leisure.

In 1899, Henrietta F. Upton took this picture of Lillian Arey at age 16 in the parlor of the House of the Seven Gables. "Lilla" is seen wearing white gloves and holding a rose. In the background is a large framed photograph of an unidentified gentleman and an unframed floral painting by Lilla's aunt Ida Upton Paine. In 1905, Lilla married William Clarke Haywood, a bookkeeper, in the same parlor.

Ida Upton Paine, seen in this portrait, was born in 1860, the first child of Henry and Elizabeth Upton. She married Frank Paine in 1895. Together, they ran an art studio on Essex Street in Salem. Ida Upton Paine created the classic image of "The Salem Witch" in the 1890s, which was available hand-painted onto china and glass.

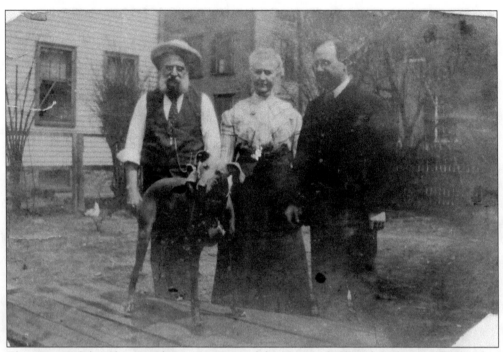

The setting of this photograph is a rare view of the Uptons' backyard at the northeast end of their property, where today Caroline Emmerton's 1915 teahouse stands. The house closest to the Uptons' property was the most recent structure added to Turner Street and is a later Victorian-style two-and-a-half-story house. The house in the center background is the Capt. John Collins House, a three-story Federal house constructed around 1785. In the above photograph, the house at right is the c. 1843 Jonathan Whipple House in a Greek Revival style. The subjects in the photograph are, from left to right, Henry O. Upton, Elizabeth A. Upton, and their son Henry Jacob Upton, who was a pianist. Standing on the platform below is Stag, the Upton family dog.

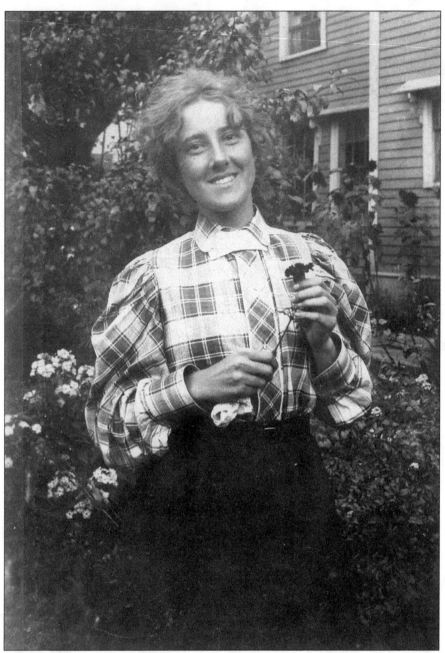

Henrietta Farrington Upton, born in 1874, was the youngest of Henry and Elizabeth's five children. She attended the Emerson College of Oratory, class of 1895, and taught oratory in the House of the Seven Gables and led children's classes in Lynn. When her father retired from his work as a dancing teacher, she took over his responsibilities. She never married and lived with her siblings at Columbus Square. In this c. 1900 photograph, Henrietta is depicted smiling and holding a flower in the gardens. Behind her can be seen the west side of the house, the windows still covered with hooded brackets. In comparison to the photograph of the garden on page 20, the trellis parallel to the house has been removed and replaced with a row of zinnias. The house's exterior has been resided and painted. The windows are now bordered with heavier, white frames.

Facing the 1676 southern addition of the house, this spring view of the gardens late in the Upton ownership shows contrasts to the view of the garden seen on page 20. The tree to the left of the front facade has matured, and the vines climbing the wall have reached to the second floor. On the far right end of the house, the addition of a veranda is visible.

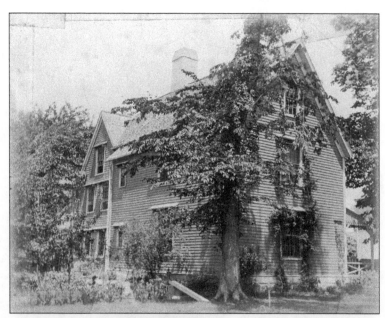

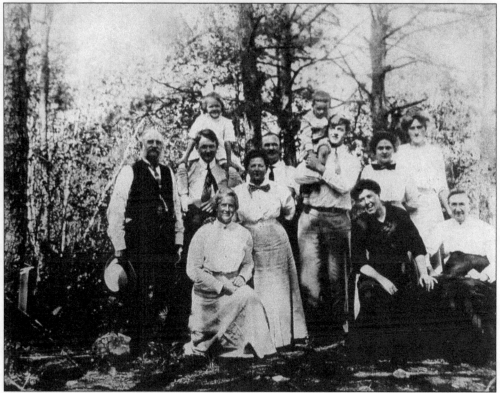

A family day at Henry Upton's camp in Middleton, Massachusetts, can be seen in this c. 1912 photograph. From left to right are (first row) Sarah "Sadie" Upton Arey, Ida Upton Paine, and Ruth Haskins; (second row) Henry O. Upton, Clarke Haywood, Addie Vanderford Haywood, Will Haywood, Ralph Haywood, unidentified, and Lillian Arey Haywood. The children sitting on shoulders are Elizabeth and William Haywood, Upton's great-grandchildren.

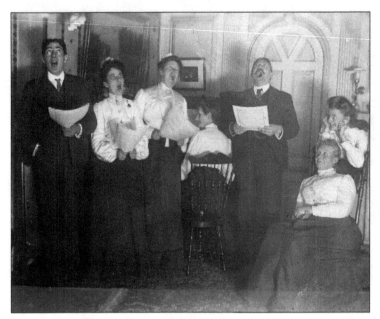

The Upton family put their musical talents to frequent use. Here, they can be seen singing in the parlor of the House of the Seven Gables. From left to right are Albert MacIntyre, Margaret MacIntyre, Ida Upton Paine, Sarah Upton Arey, Frank Paine, Helen Arey MacIlroy, and Elizabeth Upton. Scottish immigrants Albert and Margaret were family friends who lived on Loring Avenue in South Salem.

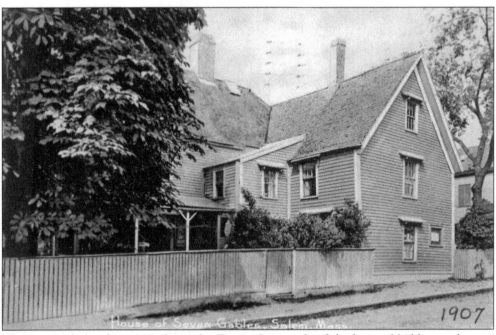

This postcard, dated to 1907, shows the Turner Street side of the house. Visible are changes from Henry Upton, including a square window in the kitchen with an inset border of colored glass. Of particular interest is a hand-painted wooden sign in the shape of a shield hanging from the veranda. The sign reads, "House of Seven Gables (Erected 1662) Admission (to House and Grounds) 25 Cents Each."

This group poses in the large room of the 1668 portion of the attic during a Halloween party. Behind them are two ghostly faces attached to the planks of the north roof of the house. From left to right are (first row) Perley Gordon, Ed MacIlroy, Ida Upton Paine, Helen Southwick, and Mary Danforth; (second row) Izette Gordon, Lillian Arey, and three unidentified; (third row) Earnest Murray, Vay Murray, and unidentified.

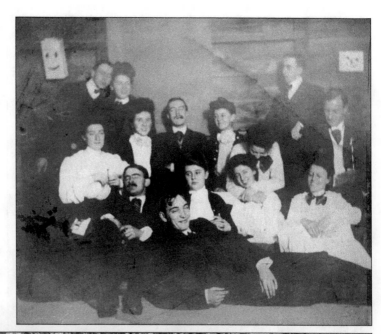

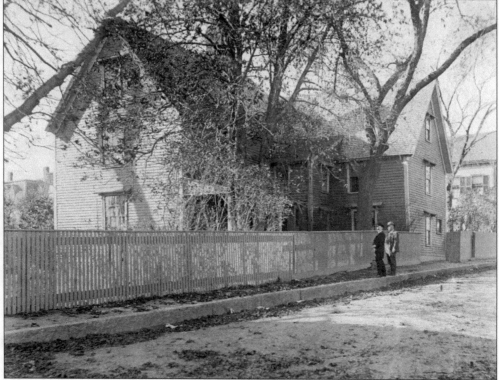

Two men stand on Turner Street admiring the House of the Seven Gables. It is late fall, and leaves clutter the sidewalk. The house appears as it did late in the Upton family's ownership, with the veranda along the east side of the 1676 addition and a small, square window in the kitchen facing Turner Street. The leaning corner posts and the sloping ground sill are evidence of the house's settling. (Courtesy Historic New England.)

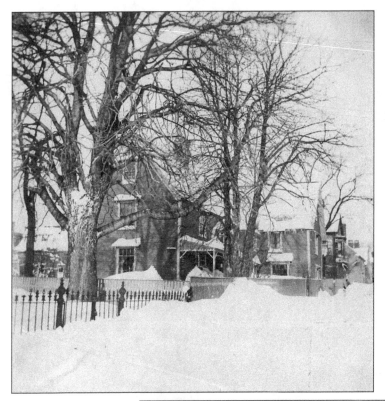

Snow blocks the way on Turner Street and blankets the House of the Seven Gables after a heavy snowstorm. An iron fence has replaced the wooden board fence closer to the harbor. A new wooden fence divides the Uptons' property from the land they sold in 1883 to the Salem Seaman's Orphans and Children's Friend Society for the construction of a ship church called the Seaman's Bethel.

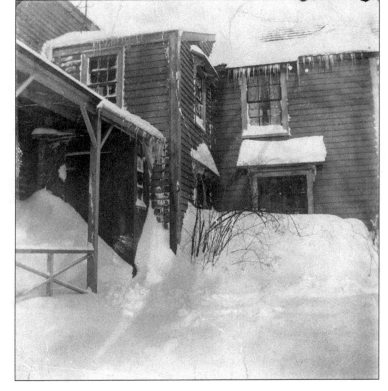

Icicles hang from the eaves, snow is piled on the windows, and drifts block the front door in this closer image of the same storm seen at right. The Uptons had this photograph resting on the mantel in the parlor, as can be seen in the lower photograph on page 26.

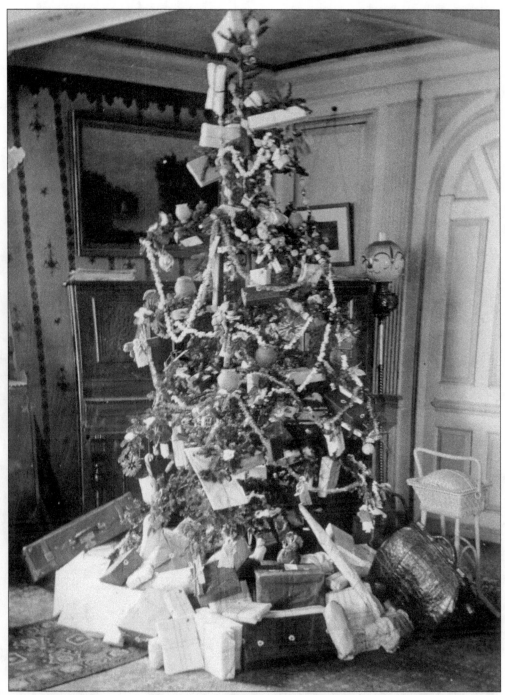

Presents are piled beneath the tree for the Uptons' Christmas in 1904. The tree almost reaches to the ceiling, and it is decorated with tinsel, strings of popcorn, dozens of ornaments, and hanging packages. This view, which shows the northwest corner of the parlor, includes the Uptons' piano, stacked with sheet music.

Lillian Arey Haywood contemplates the "Pyncheon Elm" at the House of the Seven Gables in 1942, thirty-two years after her childhood home had been transformed into a historic house museum. The Uptons sold the House of the Seven Gables to Caroline Emmerton in 1908. In the words of one of the Upton children, "It was getting too much publicity for a happy home. Too many people coming all the summer." Henry Upton's daughters—Sarah Upton Arey, Henrietta F. Upton—and Ida Upton Paine, moved with him to 5 Columbus Square on Salem Neck. Elizabeth A. Upton passed on shortly after they left Turner Street. Frank Paine and Sarah's daughters Helen and Lillian came as well. After a decade of living at Columbus Square, Henry O. Upton passed away in 1919. Lillian Arey Haywood lived in Salem until 1970. The Upton family had fond memories of their time living in the House of the Seven Gables, and Lillian's daughter Elizabeth Upton Haywood Eaton donated a family scrapbook to the organization that includes many of the images seen throughout this book.

Three

THE RESTORATION

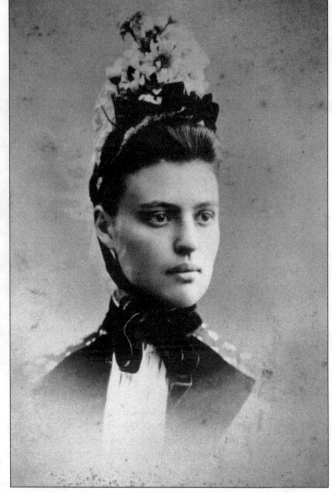

Caroline Emmerton was born in 1866 in Salem. Her father, George Emmerton, was in manufacturing and her mother, Jennie Bertram Emmerton, was involved with charities such as the Women's Friend Society, which provided housing for women; the Old Woman's Home; and the Salem Society for the Higher Education of Women. Emmerton's childhood included trips to their ancestral home in Jersey and a stay with a family in rural France.

Caroline Emmerton's maternal grandfather, John Bertram, was one of the last great figures of Salem's maritime era. He assisted in the creation of Salem Hospital and donated his home on Essex Street for the Salem Public Library. Her paternal grandfather was also successful in the merchant trade. Through this inheritance, Emmerton had a comfortable childhood. Her mother, Jennie Bertram Emmerton, was described as the wealthiest woman in Salem.

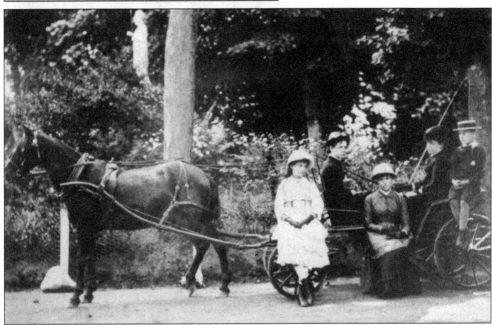

Emmerton's philanthropic endeavors were inspired by her family. By the age of 28, she was a member of the board of the Salem Seaman's Orphan and Children's Friend Society, which assisted orphaned children. Emmerton joined a committee to create a settlement house in Salem in 1907. In 1908, she established one on Turner Street and purchased the House of the Seven Gables next door. She began restoring the house the following year.

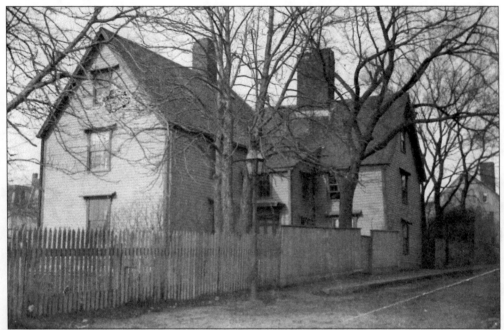

These before-and-after pictures show the changes that Henry Upton made to the property in the late 1880s. The above photograph depicts the house as Horace Connolly left it. Still visible is the 17th-century chimney in the earliest portion of the house. In the photograph below, taken from almost the same angle, is seen the thin chimney called a spindle stack, which served coal stoves rather than large fireplaces. Caroline Emmerton wrote that Henry Upton was inspired to remove the earlier chimney because "this old chimney was laid in clay instead of mortar, and there were holes in it where the clay had fallen out, so it did not seem safe." Furthermore, "its great size caused the wind to rush down it, driving flames out of the kitchen stove." The reduction of the chimney's size increased the kitchen's size by a third and gave the Uptons space on the second floor for a bathroom. (Below, courtesy Phillips Library, Peabody Essex Museum, "54 Turner St.," filed photographs, Turner Street (1-54) House of Seven Gables.)

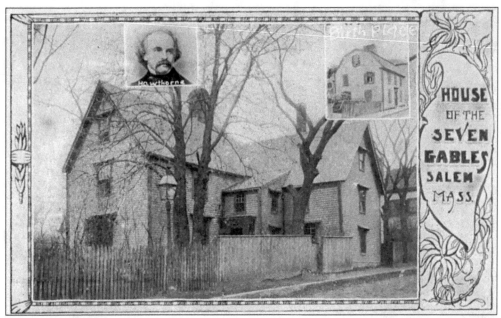

This postcard from 1904 shows the interest in the house in spite of changes to the structure over time. Many early postcards depicting the house survive, attesting to its popularity and iconic status. The inset images, a portrait of Nathaniel Hawthorne and a photograph of his birthplace, show that the House of the Seven Gables was famous because of its connection to the author.

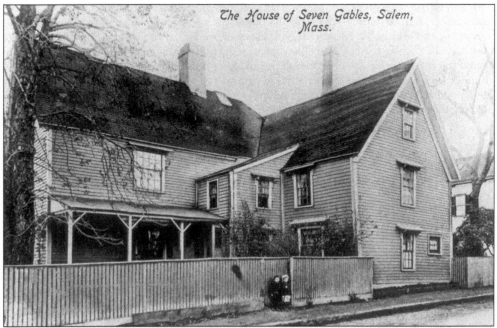

The House of the Seven Gables appears in this c. 1900 postcard as it looked shortly before its restoration. Visible on the roof of the 1676 addition is the scuttle window, useful for letting heat out of the attic or for putting out a chimney fire. Two small children stand in the gate, posing for this photograph. Like in Nathaniel Hawthorne's novel, small children often played outside of the house.

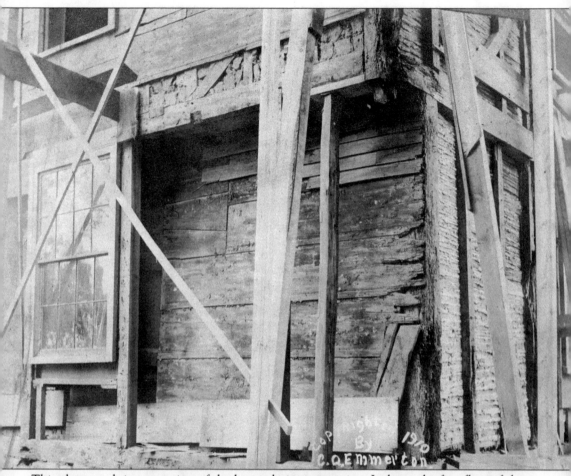

This photograph is a rare view of the house during restoration. It shows the first floor of the southeast corner of the 1676 addition. Being revealed is the original 17th-century framed overhang. In the overhang, the original brick nogging is visible. Below it, the original wide weatherboarding from 1676 can be seen. The corner of the overhang reveals evidence that once there were carved wooden pendants that hung from the frame.

The southwest corner of the 1676 addition during restoration is visible here. The 19th-century clapboarding is being stripped off to show the original siding. The weatherboards are decorated with molded edges. The ends are beveled to make the structure weather resistant. The restoration lasted from July 1909 to March 1910. The re-exposure of the overhang on the front of the house was a major discovery during this period.

Perhaps the greatest discovery during the restoration was finding a portion of the original 17th-century exterior door. Because this style of door was made of multiple boards, it was called a "batten door." Visible is the original decorative feature of wrought iron nails placed in a decorative diamond pattern. The batten door was discovered being used as a plank to seal the overhang in the late 18th century.

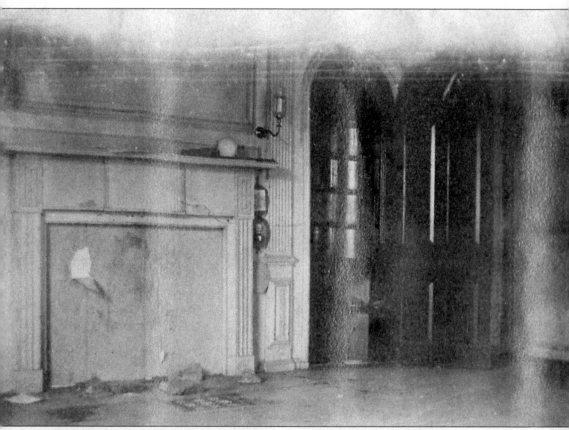

This is the parlor fireplace wall as it looked before Caroline Emmerton began restoration. The view reveals a register cut into the floor for heat, a sealed fireplace, and a later mantle. Hanging beside the fireplace are oval pictures showing Nathaniel Hawthorne and his birthplace. The Georgian cupboard now lies empty. Emmerton recorded that during the restoration of the fireplace, they discovered four consecutive fireplaces dating to different periods of the house's history.

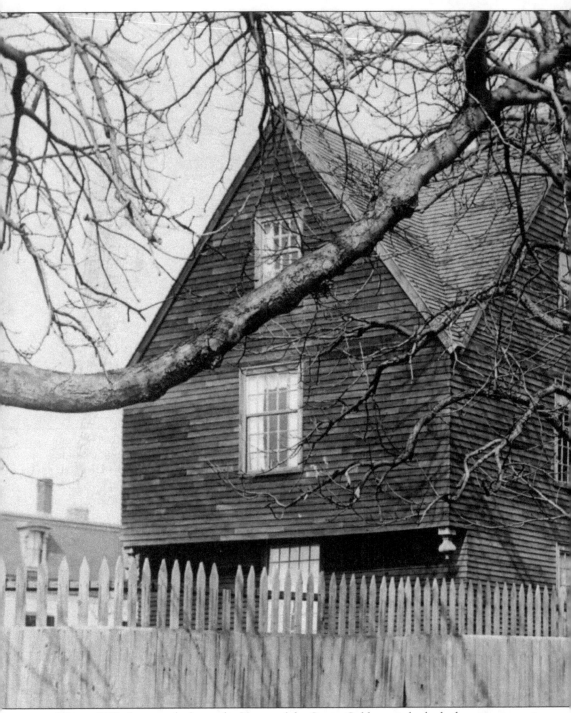

This c. 1918 photograph shows the House of the Seven Gables as it looked when its restoration had been completed. Visible at the front of the house are the restored overhang and reproduction pendants. The chimney has been enlarged back to a 17th-century size and style. Most prominent among Caroline Emmerton's changes to the structure was the return of the four missing gables. The gables had been removed in the late 18th century to modernize the house. Emmerton and

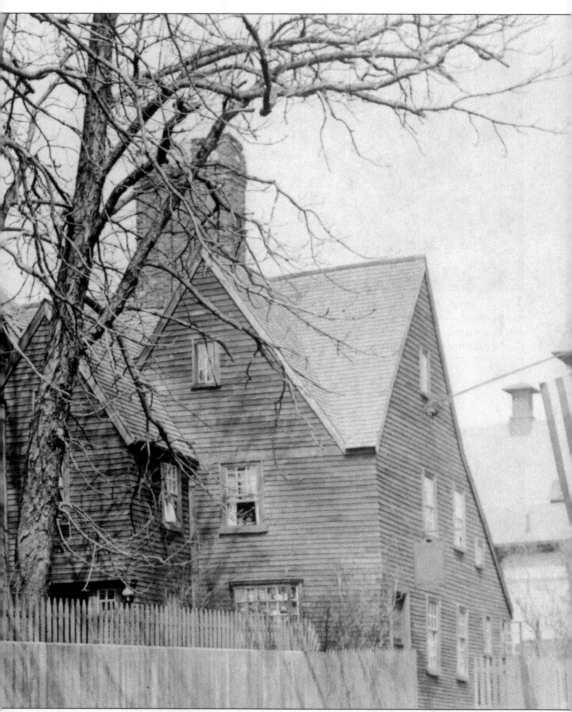

her architect Joseph Chandler studied the frame of the house and found the original mortise holes where the gables had once been. An entrance door has been cut into the Turner Street side for visitors. A sign hangs above it declaring it the House of the Seven Gables. (Courtesy Library of Congress, Prints & Photographs Division, LC-USZ63-115767.)

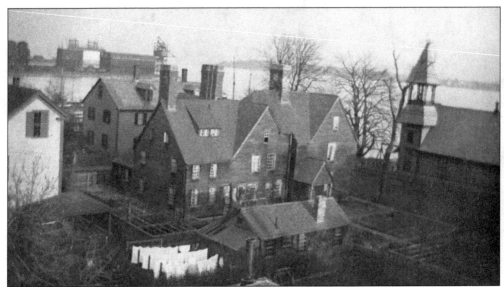

This bird's-eye view of the house was taken from the roof of the Joshua Phippen House (1782) on Hardy Street. Visible are the additions of a north wing and a garden porch. The Seaman's Bethel can be seen between the house and the harbor. The shed in the foreground is what is today called the "Counting House." At the side of it can be seen an unfinished addition.

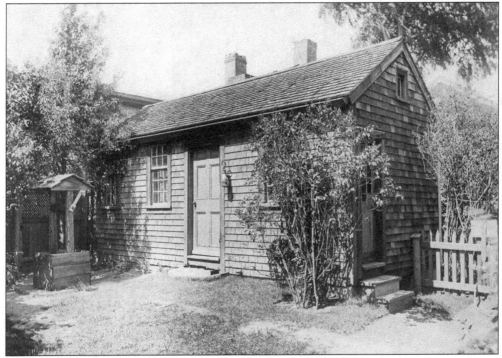

The Counting House is a mysterious building that has had several locations on the property. Elizabeth Haywood Upton Eaton, great-granddaughter of Henry O. Upton, identified the structure as his "hobby shop." This picture shows the house after Caroline Emmerton's restoration. She has reshingled the structure and added an imitation well to coincide with "Maule's well" in Hawthorne's novel.

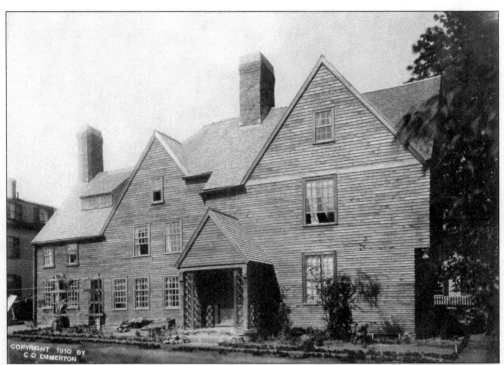

Two views of the west side of the House of the Seven Gables are shown here shortly after the restoration. The garden porch was added by Caroline Emmerton for the use of the settlement workers who lived in the house. The windows to the attic, where it could get quite hot, are open. So too are the windows at left, where the private quarters of the settlement workers were located. The above photograph, dated to 1910, shows the early stages of the garden. There are only simple plantings and a trellis. Behind the trellis can be seen the stump of the apple tree. The photograph below, taken several years later, shows the garden in its more developed form. Added were the raised beds for plantings and the wooden arbors based on an early-19th-century example at the Andrew-Safford House (1819). (Above, courtesy Phillips Library, Peabody Essex Museum, C.O. Emmerton, "54 Turner St. west side of House of Seven Gables," 1910, filed photographs, Turner Street (1-54) House of Seven Gables.)

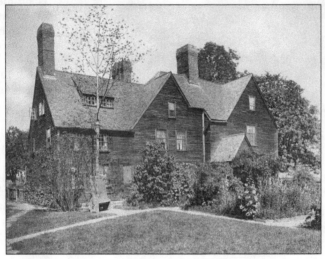

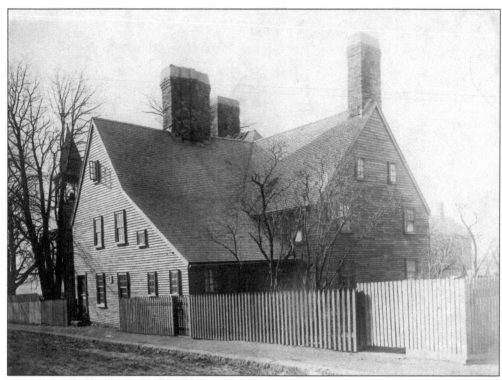

Taken from the northeast side of the house, this picture shows an early view of the re-created north wing and lean-to. At the top of the house (at left) can be seen Caroline Emmerton's re-created pilastered chimney top. The sloping roof of the lean-to and the portion of the house below it were added by Emmerton during the restoration. Her inspiration came from the probate records of the Turner family. (Courtesy Phillips Library, Peabody Essex Museum, "54 Turner St. House of Seven Gables," 1910, filed photographs, Turner Street (1-54) House of Seven Gables.)

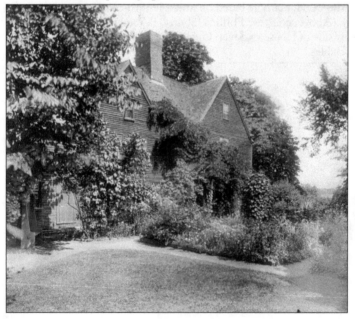

A view of the west facade of the house was taken in the summertime. The gardens are at full bloom, and the trailing vines that wrap around the garden porch have reached the roof of the house. Today, the area surrounding the garden is paved with brick pathways. As can be seen, originally this area was a grass lawn. (Courtesy Phillips Library, Peabody Essex Museum, "The House of Seven Gables view from the garden," filed photographs, Turner Street (1-54) House of Seven Gables.)

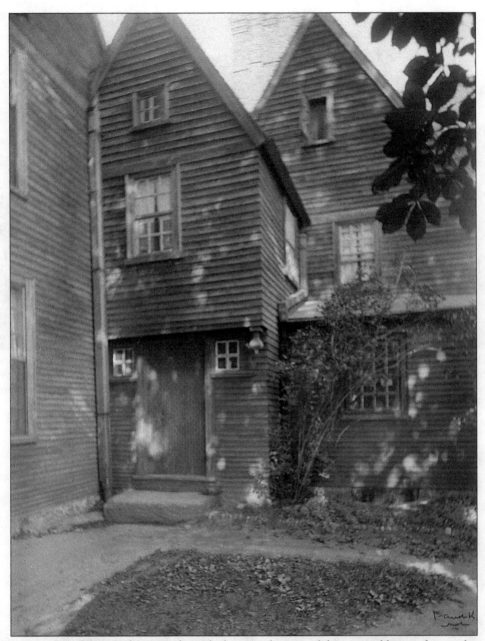

As visitors exit the tour, they pass through the reproduction of the original batten door and step onto a large stone doorstep. Most 17th-century houses were built facing south where the sun was strongest. In the case of the House of the Seven Gables, that also meant facing Salem Harbor. Between the front door and the water were the Turners' wharf and warehouses. This doorway is the main entrance to the house from Turner Street. This entrance, modeled after a 17th-century, two-story projecting porch, is designed to look like what would have been on the house in its earliest days. Note the overhanging second floor with its decorative pendants, which can still be seen today. At right can be seen the expansion to Hepzibah's Cent Shop, which also served as the museum's gift shop and entrance. The photograph was taken by the Maynard Workshop of Waban, Massachusetts.

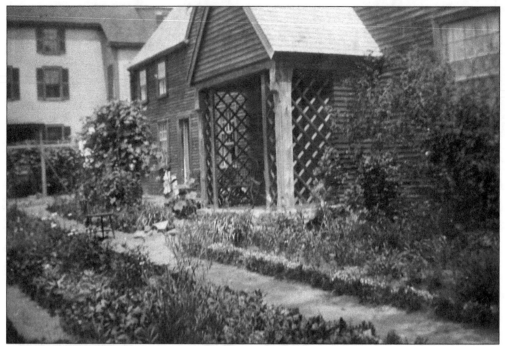

The garden porch was added to the house during the restoration between 1909 and 1910 by Caroline Emmerton. The garden that is seen in this image predates the Jacobean-style knot garden that Joseph Chandler designed in 1924. The house seen in the left background stood for only about 25 years until it was moved to accommodate the relocation of the Seaman's Bethel.

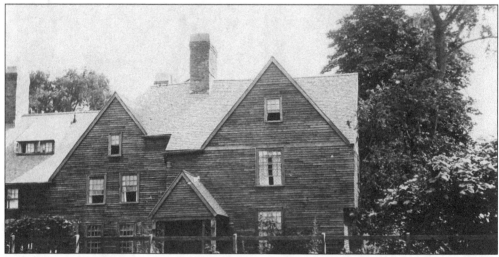

Taken from an abutting property on Hardy Street, this image shows the house shortly after restoration. The early garden has been planted, and flowers are blooming. The large north ell at left was believed to have existed from the time of the Turners in 1693 as a "kitchen ell" but removed later in the house's history. Caroline Emmerton re-created it but later regretted its placement.

This photograph shows that the restoration of the House of the Seven Gables has been stalled due to the snow during the winter of 1909–1910. The canvas hanging from the roof to the ground covers unfinished repairs to the Turner Street side of the south ell. A snow-covered sawhorse can be seen at lower left. This photograph was likely taken by E.G. Merrill, a Salem-based portrait and architectural photographer.

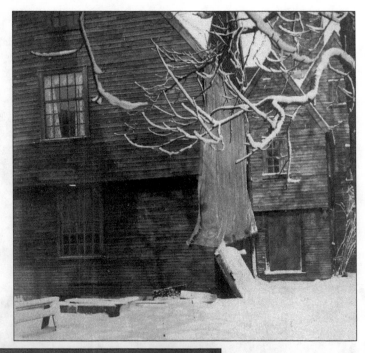

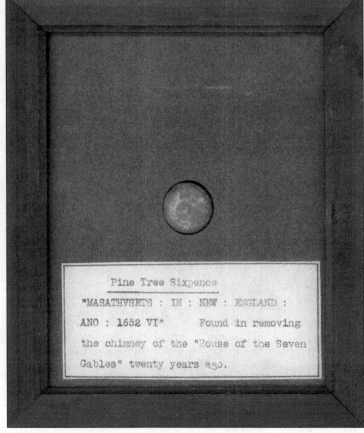

Pine Tree Sixpence

"MASATHVSETS : IN : NEW : ENGLAND :
ANO : 1652 VI" Found in removing
the chimney of the "House of the Seven
Gables" twenty years ago.

Mounted and framed by Caroline Emmerton, this early New England coin is a key piece of the mystery surrounding the "Secret Staircase." According to Emmerton, the pine tree sixpence (struck between 1667 and 1672) was discovered during the removal of the earlier chimney around 1888. Emmerton used the coin as evidence that a staircase once existed in the chimney as she built a new secret passageway in the restored home.

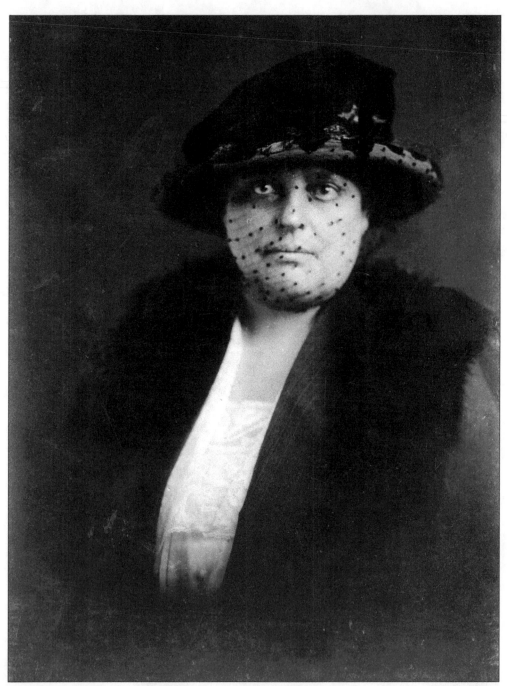

Caroline Emmerton died on March 17, 1942. The *Salem Evening News* obituary calls her "one of Salem's best beloved citizens," and notes that she "gave freely of her time and money for the benefit of underprivileged children and adults, winning the admiration and respect of the entire community." In 1999, the newspaper named Caroline Emmerton Salem's "Person of the Century." The mark of Emmerton's generous spirit can be found throughout Salem in the many organizations she was once involved with that survive today. Emmerton's most ambitious undertaking, the House of the Seven Gables Settlement Association, has survived for more than 100 years.

Four

THE SETTLEMENT HOUSE

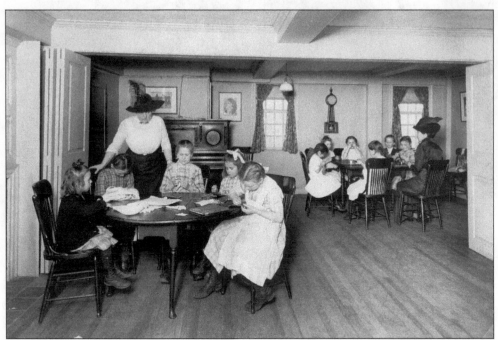

Caroline Emmerton (in the large hat at left) looks over a group of girls as they have a determined go at needlework in the parlor chamber of the Hooper-Hathaway House, which was moved to the property of the House of the Seven Gables in 1911. The "social settlement," as Emmerton called it, provided classes like this one to local immigrant children.

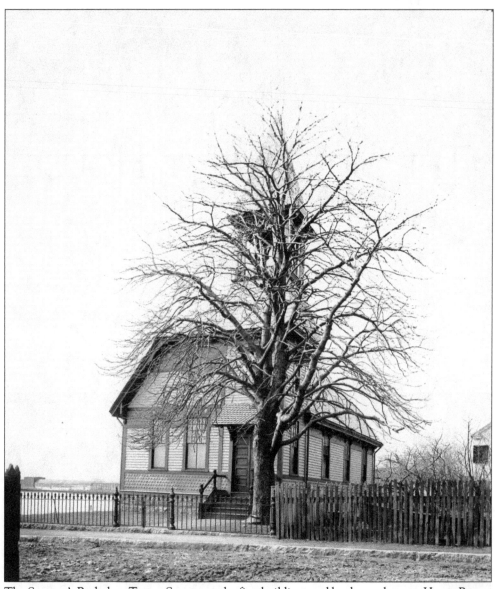

The Seaman's Bethel on Turner Street was the first building used by the settlement. Henry Barr, a captain of Salem's East Indies trade, left money in his will in 1836 for the construction of a bethel for the Salem Marine Society. When the Seaman's Bethel was finally built in 1889, Salem's trade was in decline and services were sparsely attended. In 1903, trusteeship was transferred to the Salem YMCA. (Courtesy Phillips Library, Peabody Essex Museum, "56 Turner St. Salem, Mass., Seaman's Bethel," 1890, filed photographs, Turner Street (54–57) House of Seven Gables, 173.)

This picture shows the Seaman's Bethel at its original location above the seawall at the end of Turner Street. At the time of Caroline Emmerton's acquisition, it was being used in the summer for YMCA activities. Emmerton moved the Seaman's Bethel to the north end of the property in 1914 and converted it into Turner Hall, a location for settlement activities such as gymnastics and dramatics.

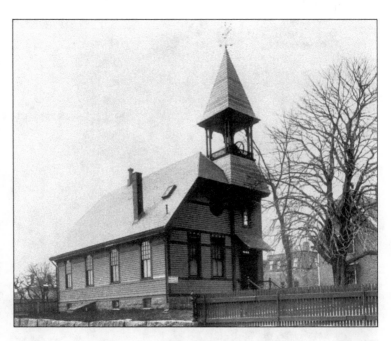

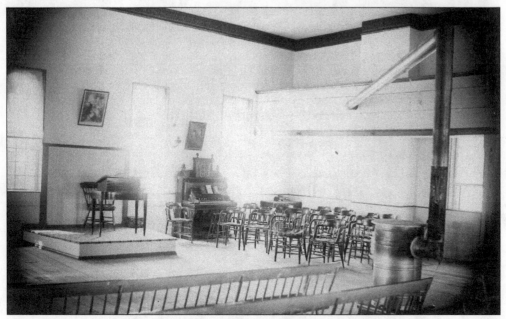

This interior view of the Seaman's Bethel shows how the church was decorated. There is a raised platform for the altar as well as an organ. There is a gallery for seating on the second level. The church was never very busy. As Emmerton wrote, "The ancient shipping had left Salem . . . Services were held in the Bethel for a number of years but it was evident there were no sailors to attend them." (Courtesy Phillips Library, Peabody Essex Museum, "56 Turner St.—the old Bethel," filed photographs, Turner Street (54–57) House of Seven Gables.)

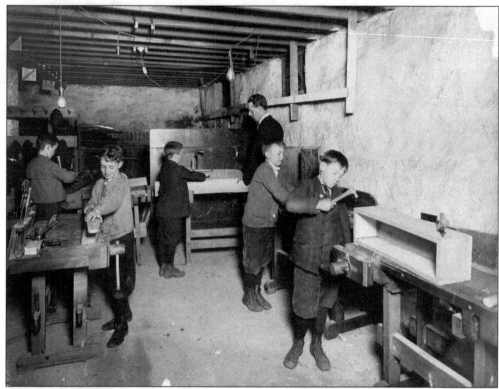

Boys involved in the House of the Seven Gables Settlement learned woodworking through sloyd techniques. Sloyd was a system of practical education created by Finnish educator Uno Cygnaeus in 1865 and widely adopted in Scandinavian countries. It gained popularity in the United States at the end of the 19th century through the efforts of Swedish educator Gustaf Larsson. The students would work on projects with a set order of increasing difficulty. As Larsson writes in the 1906 *Elementary Sloyd and Whittling*: "Sloyd is tool work arranged and employed as to stimulate and promote vigorous, intelligent self-activity for a purpose which the worker recognizes as good."

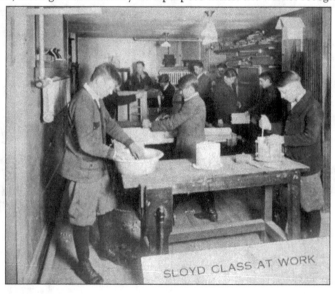

SLOYD CLASS AT WORK

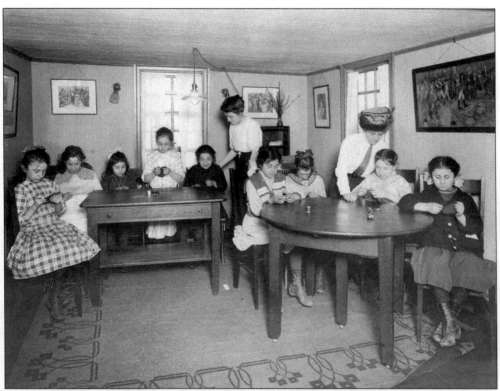

Vocational education was a cornerstone of the settlement house's program. Just as boys learned woodworking through sloyd techniques, the girls learned sewing and cooking in addition to English and American history. The above photograph was taken in a first-floor room of the lean-to of the Hooper-Hathaway House and features a group of girls learning sewing skills. In the photograph below, girls in the great room of the Hooper-Hathaway House assemble a puzzle under the watchful eyes of settlement workers. At left is a set of bookshelves, and books are scattered across the table at the back of the room. The 17th-century buildings of the property found new life with their use for settlement education.

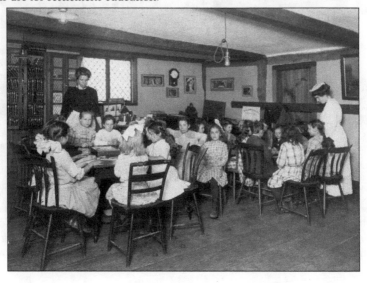

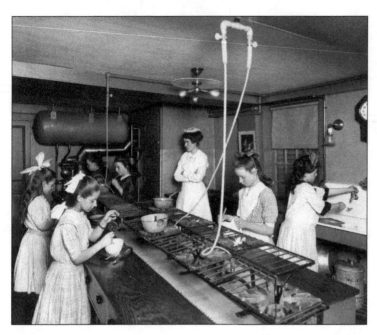

Slightly after 4:30 in the afternoon, this cooking class diligently mixes ingredients in the Hooper-Hathaway House. Cooking classes were part of the vocational education of the settlement house. There, girls learned the basics of cooking under the supervision of resident workers in "domestic science" and "domestic arts." While many classes offered by the settlement were free, the cooking classes required a nominal charge to cover the costs of ingredients.

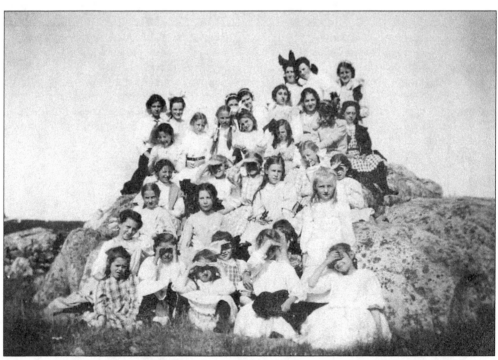

A group of girls from the House of the Seven Gables Settlement sits on a rock at Cobbett's Pond in Windham, New Hampshire. The pond, about 30 miles from Salem, was the setting for canoeing and swimming for the settlement children in the summer months. In 1915, for example, the girls went to the pond in July, while the boys went up in August.

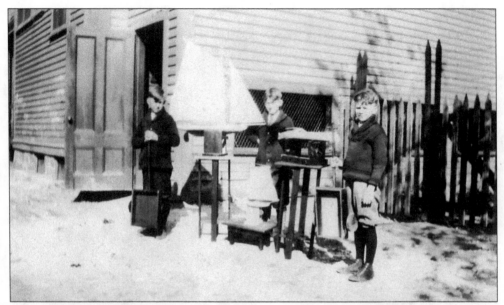

Three boys from the House of the Seven Gables Settlement pose with their pond yachts in the 1910s. Two of the boys hold wooden carts for transporting the vessels. Because woodworking was integral to the settlement program, these boys likely built the models themselves. The boys are wearing knickers, while the boy at right has a sweater with a shawl collar.

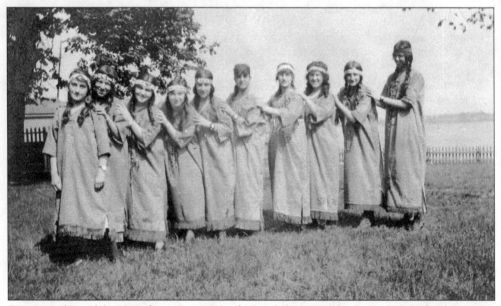

Some members of the Naumkeag Camp Fire, the local chapter of the Camp Fire Girls of America, are pictured here on the lawn. In the 1910s, a chapter was sponsored by the House of the Seven Gables Settlement Association. In 1915, the girls put on a play of Guy de Maupassant's short story "The Necklace" to raise money for their program. A troop of Boy Scouts was also sponsored by the settlement beginning in 1914.

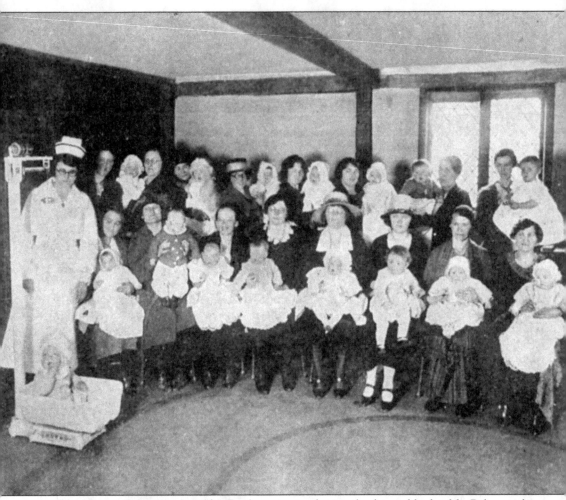

The House of the Seven Gables Settlement was also involved in public health. Baby weighing stations were an important service provided by the social settlement. In this image here, mothers wait in the Hooper-Hathaway House to have their children weighed. The weight of infants is a key metric for understanding their overall health. Forty-nine weighing "conferences" were held in the Hooper-Hathaway House during the 1928–1929 year in which 468 children were weighed. In 1916, the services of a resident nurse were secured for the settlement. The nurse made about a thousand visits to children in their homes each year. Physicians also donated their expertise for weekly clinics to help the workingmen and -women of the neighborhood. In the words of the *1916–1917 Annual Report*, "The discovery of neglected ailments and premonitory symptoms of preventable diseases which may endanger the health of the family and the community is most necessary." After the Great Salem Fire of 1914, the House of the Seven Gables was also designated a station where milk could be procured for babies.

Children play
candlepin on a patch
of dirt on Hardy
Street where the
Nathaniel Hawthorne
Birthplace is located
today. One girl sits
in a sandbox. Behind
them is the Hooper-
Hathaway House,
the back chimney
and entranceway of
which no longer exist.
A fence separates
the playing children
from the garden and
tearoom guests.

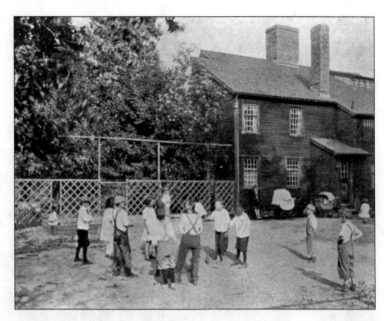

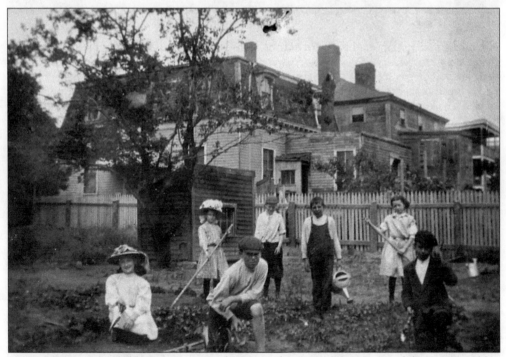

In this photograph, children are seen gardening to the west of the House of the Seven Gables, where the Retire Beckett House sits today. Gardening was an activity of the settlement. In the background are the Joshua Phippen House (1782), at far right with its lost front ell, and beside it the Rowell House, which was destroyed in a fire in 1966.

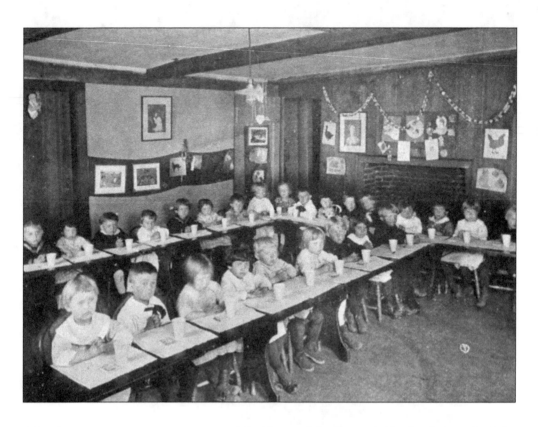

A kindergarten was an important part of the House of the Seven Gables Settlement. In 1914, there were 62 students, and in 1920, there were 50 students. In the above picture, the children eat their lunches on the second floor of the Hooper-Hathaway House in 1920. In November of that year, a lunch of crackers and milk was undertaken at a cost of 4¢ per child. The picture below is labeled "the kindergarten group with the mothers—plus Beth and Lyle." They are seated on the front lawn by the seawall, with the shore of Marblehead in the background.

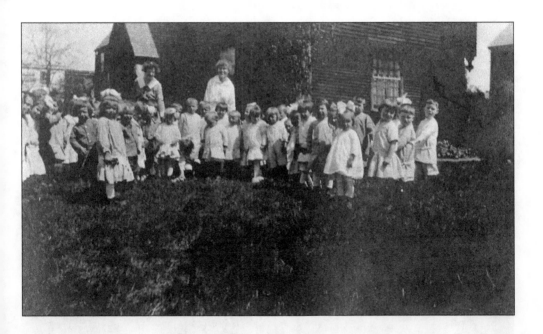

The kindergarten met between October and June, and the assistants came from the Wheelock Kindergarten Training School in Waltham, and later from Boston. Ninety percent of the students were learning English as a second language. The majority nationality was Polish, and the Polish Women's Club formed from mothers of kindergarten children. Meetings for the mothers included amusing re-creations of their children's activities. When the kindergarten was discontinued in the summer because the college assistants went on break, a post-kindergarten program was arranged where smaller groups of children participated in activities in the garden. These two images show groups of young students on the lawn in front of the House of the Seven Gables.

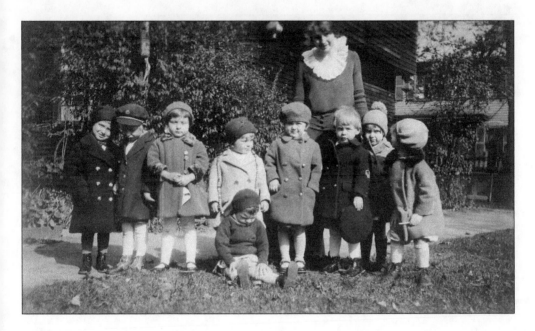

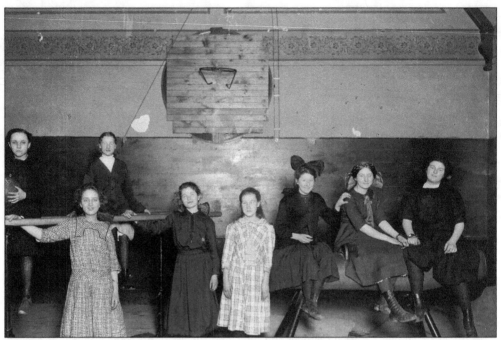

When the Seaman's Bethel was relocated in 1914 and renamed Turner Hall, a gymnasium was added to its facilities. Here, girls who are a part of the settlement program sit on the parallel bars and pommel horse. There are mats on the floor in the background, and the girl at far left holds a medicine ball. A resident worker ran the gymnasium and gave classes in gymnastics and physical fitness.

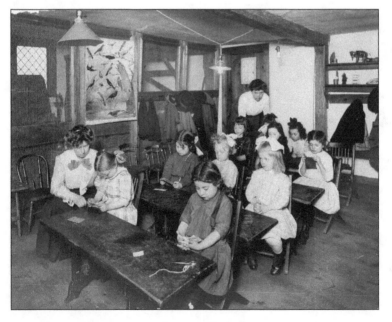

This sewing class is taking place on the first floor of the Hooper-Hathaway House. Settlement instructors assist the girls with their work. A wire screen divides the room, and coat racks are hung with the children's coats and hats. A large poster of native birds hangs at left, and at right, a series of toys can be seen on the shelves.

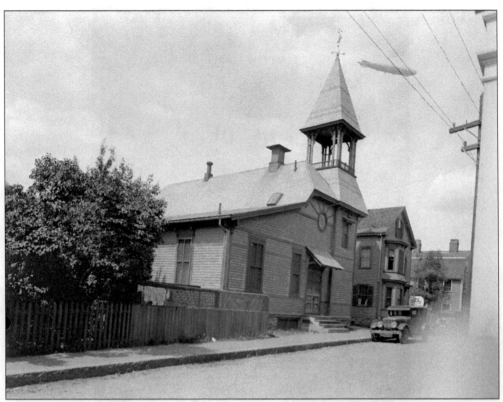

The above photograph depicting Turner Hall with a blimp flying in the sky behind it was taken by Boston architectural photographer Leon Abdallian on August 16, 1929. A sign on a neighbor's house offers free parking for patrons of the House of the Seven Gables. By moving the Seaman's Bethel down the street and enlarging the building, the settlement increased its number of rooms for classes and meetings from two to seven. Added as well were a library and reading room, showers, a kitchenette, and a large room that served a dual purpose as a gymnasium and a theater. The photograph at right shows a later view of Turner Hall after a second floor was inserted, necessitating the replacement of the porthole window on the second floor.

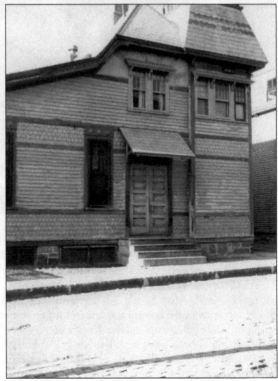

Two boys from the settlement program wear homemade ghost costumes around Halloween time. They have mittens hanging loose at the end of their coats. Because of the ghastly legacy of the Salem Witch Trials, Salem became associated with Halloween and the macabre in the 19th century. Nathaniel Hawthorne draws on this grim aspect of Salem's past in *The House of the Seven Gables*. The novel opens with the greedy Colonel Pyncheon falsely accusing Matthew Maule of witchcraft to steal his land. After Maule is hanged and the Pyncheon family builds their house on the site of his, a bloody curse haunts the family for generations. The novel, a Gothic romance, features various macabre elements, such as the ghost of Alice Pyncheon, driven to madness by mesmerism inflicted on her because of her father's avarice. The novel increased Salem's dark appeal to curious visitors. After the introduction of Haunted Happenings, a monthlong Halloween celebration, in the 1980s, seasonal tourism grew tremendously in the city.

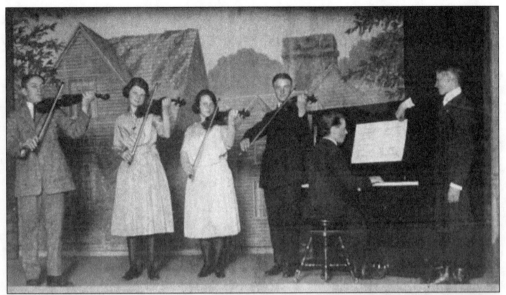

A musical performance takes place in Turner Hall in front of a backdrop showing the House of the Seven Gables during the 1921–1922 academic year of the settlement house. The violin teacher was Lucy Dennett, and piano was taught by Lottie Larcom. In that year, 346 piano lessons and 830 violin lessons were given as part of the settlement, and four such recitals were held.

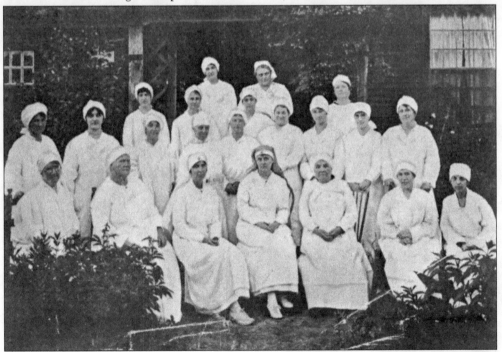

Red Cross Surgical Dressings Workers of the House of the Seven Gables are picture here in front of the summer porch of the house in 1917 or 1918. The group was formed of local Irish, Polish, and Russian immigrant women who prepared surgical dressings for World War I under "expert supervision." The group, which included 44 women who had not previously been involved with the settlement, produced 15,747 dressings.

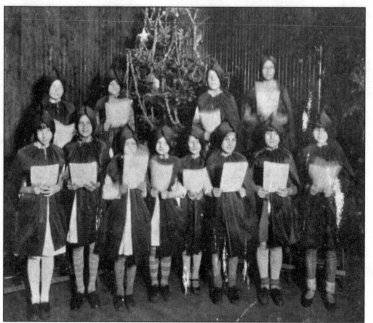

This image of children caroling comes from the *1928–1929 Annual Report of the House of the Seven Gables Settlement Association.* Starting in 1914, children from the settlement house sang Christmas carols at the Old Ladies' Home, the Bertram Home for Aged Men, and parochial schools in the neighborhood. The children would also make presents to bring to the almshouse on Salem Neck. These traditions continued into the 1930s.

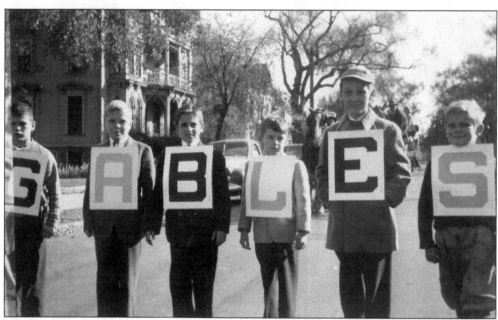

Young boys from the settlement house carry placards that spell out "Gables" in a local parade in the 1940s. The House of the Seven Gables has been an iconic part of the Salem community for more than a century. Settlement programs continue at the House of the Seven Gables today, and involvement in the community is an integral part of the organization's mission.

Five

A Tour of the House

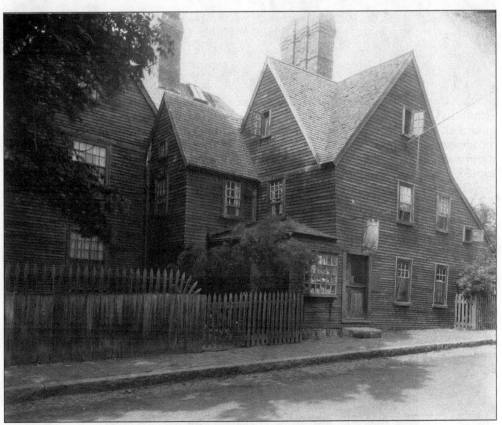

Beginning in 1910, the House of the Seven Gables was open to the public for guided tours. Guests arriving for a tour would enter through the door at 54 Turner Street into the former kitchen of the Upton family, which was partially re-created into Hepzibah's Cent Shop. This was where the tour began, and it also served as the gift shop.

Hepzibah's Cent Shop in the House of the Seven Gables is pictured before its 1913 expansion. The mock 19th-century cent shop is overflowing with souvenirs. Caroline Emmerton used this space for admissions and as a gift shop. It was not unusual to find a fine house in Salem with a store integrated into one of the ground-floor rooms to sell sundry goods. When Nathaniel Hawthorne wrote his novel *The House of the Seven Gables*, he used inspiration from the many shops found in Salem homes to create the fictional shop run by Hepzibah Pyncheon.

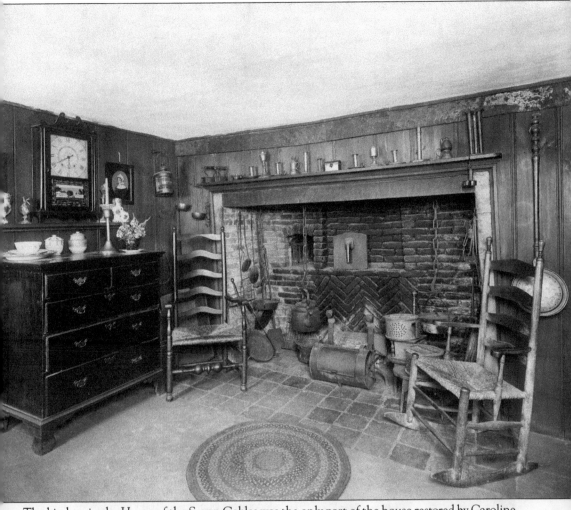

The kitchen in the House of the Seven Gables was the only part of the house restored by Caroline Emmerton and Joseph Chandler to interpret 17th-century life within the house. Among the major features that were re-created was a large, open hearth with a brick oven, set with the utensils and cookware found in early New England homes. The wall seen at left is a thin partition added during the restoration to make room for Hepzibah's Cent Shop, which lies directly on the other side, splitting the original room in two. This is a typical Colonial Revival interpretation of a 17th-century kitchen. Colonial Revivalism was a reawakening in the second half of the 19th century of American colonial history and aesthetic that prompted a wave of romanticized restorations of old houses throughout New England. Though this room is largely restored, early architectural features can be seen throughout, including the exposed posts and beams.

EMMERTON ©

This room, known as the dining room, was part of the 1668 construction of the house. As architectural styles progressed into the 18th century, exposed posts and beams were encased in paneling and fireplace walls were embellished with raised field paneling and decorative pilasters in the Georgian style. To the left of the fireplace is a thin, arched cupboard door that opens to reveal a wood closet. Behind the wood closet is a secret that has delighted visitors since 1910.

The entrance to the famous secret staircase is seen here. The staircase was added between 1909 and 1910 by Colonial Revivalist Joseph Everett Chandler. This narrow, winding staircase ascends two floors into the garret. Over the years, there have been various and conflicting explanations for its existence. Some of these explanations include smuggling, hiding from witch-hunters, and use in the Underground Railroad. None of these theories have ever been proven.

Located in the garret, this small bedroom is interpreted as the bedroom of Clifford Pyncheon, a pitiable character from Hawthorne's novel. In the story, Pyncheon makes an unexplained appearance on the first floor after an exhaustive search for him in the house by his sister Hepzibah. The secret staircase that enters into this room from the dining room is interpreted as Clifford's means of moving mysteriously throughout the house.

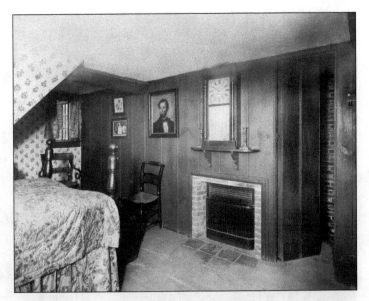

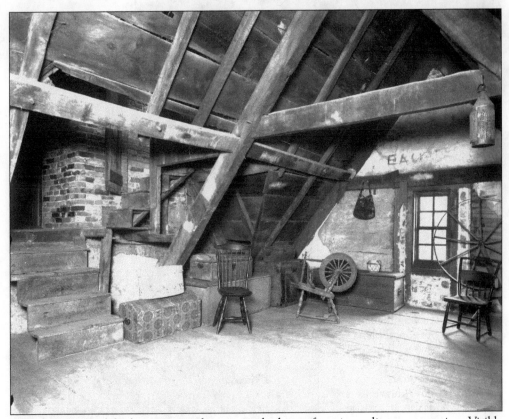

The attic is one of the best-preserved rooms in the house from its earliest construction. Visible are the principle rafters, collar beam, tree nails (trunnels), brick nogging, and original wide-plank floors. This room provides visitors with an unparalleled look at 17th-century architecture. Visible on the back wall is one of the gables, a double-sloped roof that forms an inverted V shape.

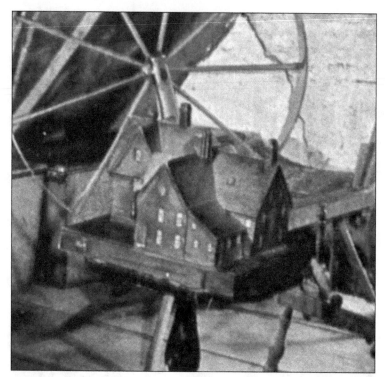

An informative part of the tour is the model of the house, which can be disassembled to show how the house has evolved throughout the centuries through various renovations. The model provides guests with a microcosmic view of the house's architectural history over the years. The current model of the house used on the tour replaced this original one now in collections care.

This is a piece of the original batten door that was found during restoration of the overhang on the south ell. A batten door is a door made of vertical and horizontal planks fastened together with iron nails. The diamond-shaped pattern on the front is a decorative feature known as diapering. This was an artistic technique that involved small, repetitive geometric shapes set close to one another to form a pattern.

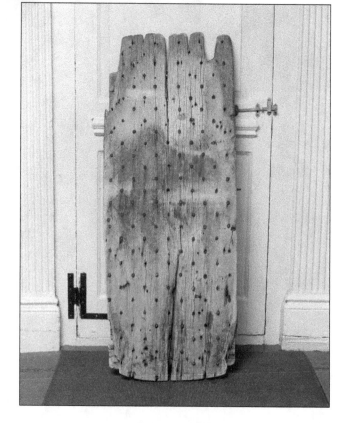

The great chamber of the house is an impressive room today, just as it was in 1676 when it was built. This room reflects the wealth and prominence of the Turner family that constructed it. The ceilings are higher in this room, and the window seats, wainscoting, and crown molding are evidence of the expansive renovation to the house during the Georgian period. In Nathaniel Hawthorne's novel, this is known as "Phoebe's Room."

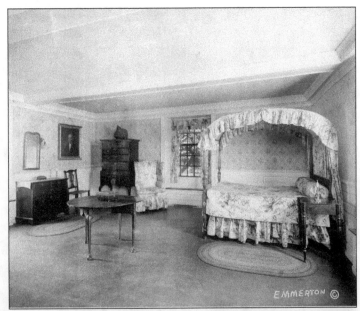

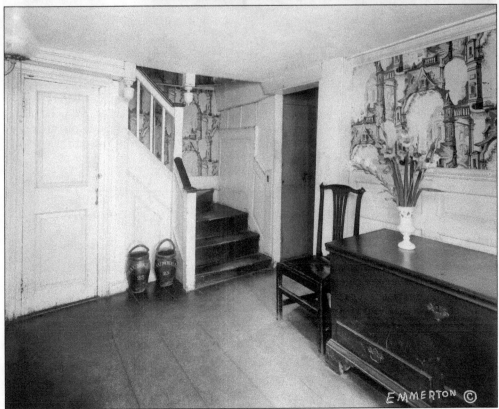

This view shows the interior of the entrance hall with the main staircase seen at the back. Guests on the tour descend the staircase from the second floor. When they reach the bottom of the stairs, they see multiple doorways leading into various wings of the home. This would have been the main entryway for the families living in the house.

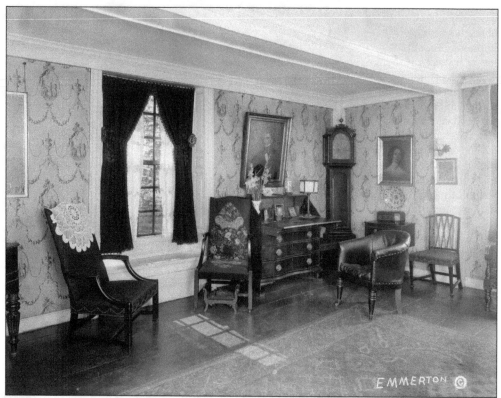

The parlor was the formal gathering place for entertaining guests and dignitaries. Often, the best furniture and decoration could be seen in the parlor. The "Diana" wallpaper was found during restoration and re-created. This would have been the room in which Susanna Ingersoll entertained her cousin Nathaniel Hawthorne. A favorite pastime of theirs was playing the card game whist. Portraits of the two hang near each other in the corner of the room.

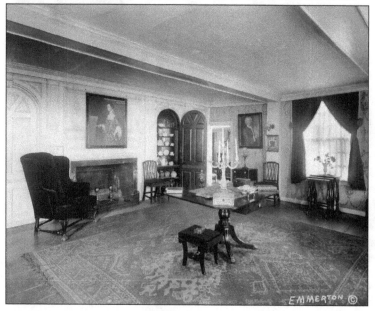

Another view of the parlor shows the 18th-century paneling added by the wealthy and prominent Col. John Turner II. The portrait to the right of the door is of John Turner III, the last member of the Turner family to own the house. The open door reveals the shellback china cabinet, and above the fireplace is a portrait of Mary Turner Sargent, daughter of John Turner III.

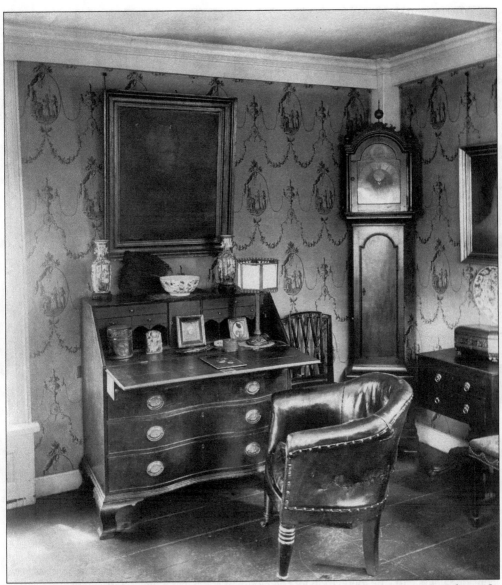

Nathaniel Hawthorne was the most famous visitor to the house during its time as a residence. In this photograph is seen the desk at which he wrote *The Scarlet Letter* while living at 14 Mall Street in Salem and his favorite leather upholstered chair. The House of the Seven Gables has acquired a multitude of artifacts and memorabilia from the life of Salem's most famous son, which are on display in his birthplace. His novel tales of both *Grandfather's Chair* and *The House of the Seven Gables* originated from his visits to this house and his cousin Susanna Ingersoll. It is because of Hawthorne that the house has achieved its immortality.

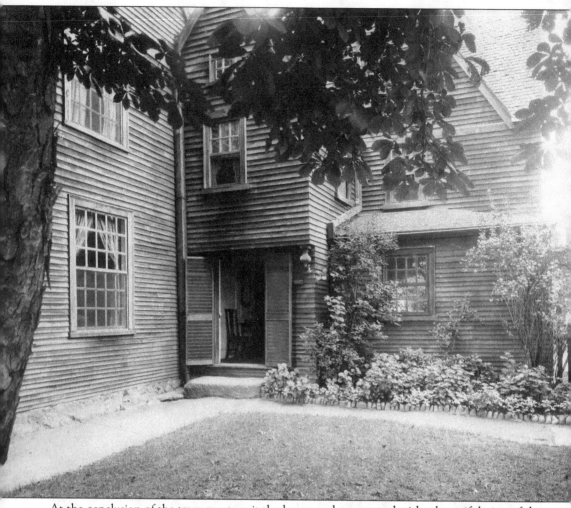

At the conclusion of the tour, guests exit the house and are greeted with a beautiful view of the grounds and Salem's harbor, along with the other houses that make up the museum campus. With over 100,000 visitors each year, the House of the Seven Gables is one of the most visited historic house museums in the country. Without the creative genius of Nathaniel Hawthorne and the unbounded vision of Caroline Emmerton, the house may have been lost forever. From these two icons of Salem's past, the foundation for the House of the Seven Gables Settlement Association was established and continues to this day.

Six

EARLY DAYS
AS A TOURIST SITE

This poster celebrates the opening of the House of the Seven Gables as a tourist site on April 30, 1910. Below an illustration of the house and its gardens are listed the names of 22 guests present on opening day. At the end are four architecture professors from the Massachusetts Institute of Technology, the alma mater of Joseph Everett Chandler. Among them is Constant-Désiré Despradelle, an influential Beaux-Arts–style architect.

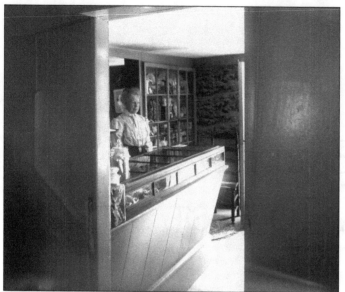

Behind the counter of Hepzibah's Cent Shop stands Miss Pyncheon's early-20th-century stand-in. This unidentified staff member is overseeing the gift shop and greeting guests as they arrive at the home between 1910 and 1913. Taken from the entryway of the house, this photograph shows the entrance to the kitchen behind her, which is where the tour began. The cabinet behind her and the shop counter are full of souvenirs available for purchase.

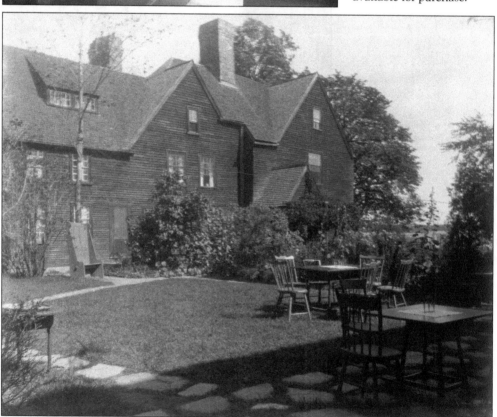

This photograph was taken by the Maynard Workshop of Waban, Massachusetts, in the 1910s or 1920s. It shows the garden and back lawn of the property with tables arrayed for guests. Walkways paved with stones lead to the tour. Visible at left are the curtained window where settlement workers lived in the re-created north ell and second floor of the 1668 house, hinting at the dual use of the property.

This group of five stands on the lawn to the west of the house in the early 1910s. Behind them can be seen the Counting House at its original location. In the background at right is a three-story tenement house, later demolished. In the center is the Joshua Phippen House, seen with a two-story rear ell, which was later removed. At left is the Rowell House, which became a bed-and-breakfast.

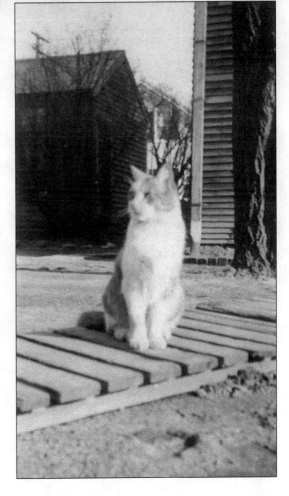

Neighborhood cats have played a role in entertaining visitors at the House of the Seven Gables for decades. This image from the 1930s shows Calico the cat waiting to greet guests as they walk the grounds. The building seen at left is the Counting House on one of its prior locations near the House of the Seven Gables.

A line of girls wait outside the door of the re-created north ell. This section of the house was not open to the general public and was used for the purposes of the social settlement. In this photograph, it has a Red Cross emblem on the door. The room behind them later became the waiting room for tours.

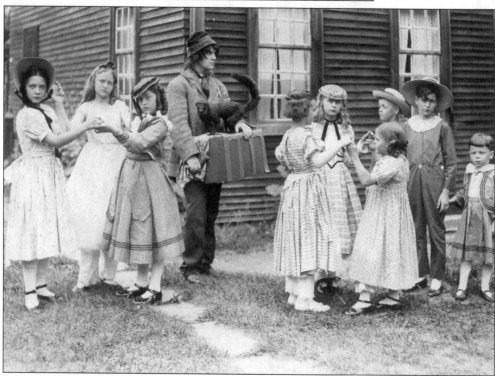

In 1920, Caroline Emmerton staged an outdoor play of *The House of the Seven Gables*, which she adapted herself. Here, John Pickering portrays the organ grinder from the novel. The children are, from left to right, Ellen Quincy Kennard, Rebecca Benson, Margaret Nichols, Libby Saunders Drummond, Mary Ives Borden, Francis Donaldson, Octavia Peirson, Ed Carroll, and Jimmy Mulligan. They stand in front of the north wing of the house.

Judge Alden Perley White is seen here dressed as Colonel Pyncheon for act 1 of Caroline Emmerton's play of *The House of the Seven Gables* in 1920. Beside him is William E. Northey Jr. playing young Gervaise Pyncheon. The first act is set in Salem before 1700 and is based on the first chapter of Hawthorne's novel, when Colonel Pyncheon steals the land of Matthew Maule.

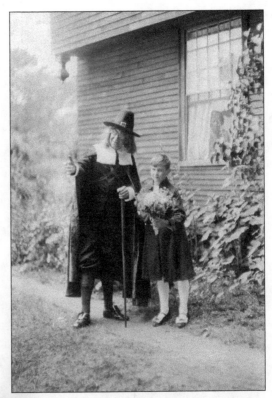

Two "lady customers" to Hepzibah's Cent Shop are seen here ready for act 3 of Caroline Emmerton's play. They are portrayed by Elizabeth Trumbull (left) and Sally Daland, who stand at the front door of the house. In Emmerton's script, the ladies shop for yeast cakes, cotton, and baskets. In the novel, bars of soap, tallow candles, brown sugar, and elephant cookies are among the other items available in Hepzibah's shop.

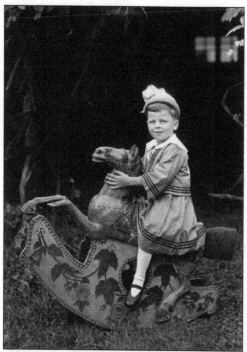

This c. 1922 picture shows a young John Mulligan Jr. sitting on a hand-carved, hand-painted wooden rocking horse. He is under the grape arbor of the tearoom on the lawn of the House of the Seven Gables. Caroline Emmerton acquired this rocking horse, along with other antiques, to create an atmosphere reminiscent of bygone days. The photograph was taken by James Mulligan Sr., of Federal Street, in Salem.

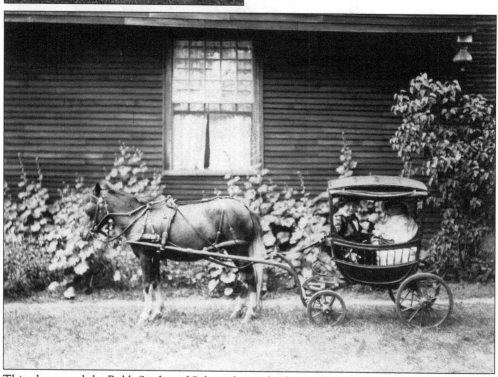

This photograph by Robb Studio, of Salem, shows the front of the house on a summer day with the parlor window open. Hollyhocks grow against the clapboards, and a lilac bush blooms at right. A pony pulls two children in a miniature coach. They are well dressed for the occasion. A curtain for shade is rolled at the roof of the coach.

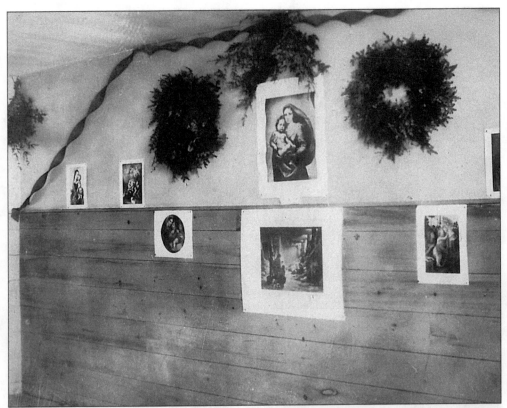

This image depicts the first exhibition shown at the House of the Seven Gables. It dates either to 1923 or 1924, when Caroline Emmerton organized a show of Madonnas and other works with Christmas themes by painters of the 15th and 16th centuries. The show was organized to raise funds for the Christmas programs at the House of the Seven Gables Settlement. It was so popular in 1923, it was revived the following year.

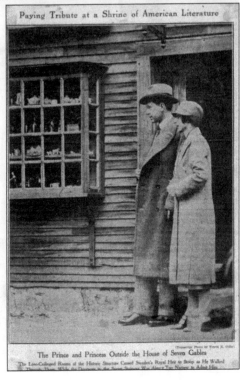

Paying Tribute at a Shrine of American Literature

The Prince and Princess Outside the House of Seven Gables

Crown Prince Gustaf Adolf and Crown Princess Louise of Sweden visited the House of the Seven Gables in June 1926 as guests of Harold Jefferson Coolidge Sr., of Boston and Pride's Crossing. According to the *Boston Daily Globe*, "The Crown Prince had to stoop in the quaint, low-ceilinged rooms." The crown prince became King Gustaf VI Adolf of Sweden in 1950 and reigned until his death in 1973.

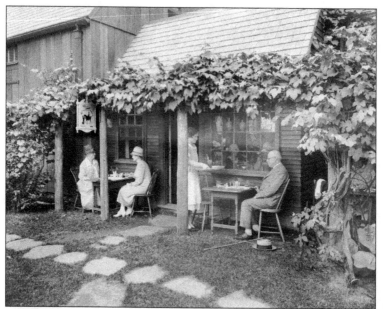

Tea was served to the public at the site beginning in 1910. The tearoom seen in this photograph by L.O. Tilford was built in 1914 "to meet the needs of a growing business," as Caroline Emmerton wrote. The sign at left reads, "A stirrup cup of ice cold fruit punch always on tap." A server hands the gentleman at right a glass of punch or iced tea.

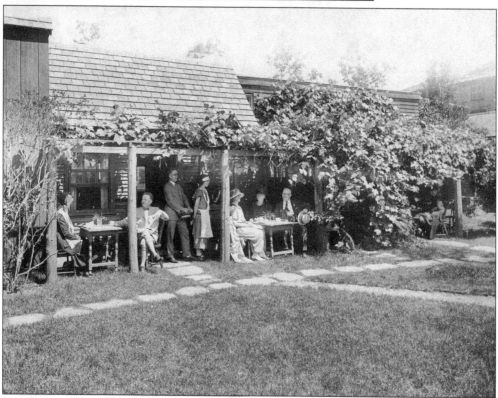

This photograph shows visitors enjoying their tea in the shade of the tearoom's arbor. According to Caroline Emmerton's handwritten notes, "The exterior, a simple shed, looks appropriate in the grounds and in harmony with the other buildings. The interior is frankly a well-appointed modern tearoom." The tearoom stood to the northwest of the house, and a portion of it still survives as part of the present visitor center.

Over by the front of the Retire Beckett House, three women are served lunch at the tearoom in the 1920s. Beginning in 1925, the tearoom served meals and sold cigars to raise money for the settlement house. A contemporary article in the *Boston Daily Globe* notes "there is seldom a pleasant night when a number of happy parties may not be seen grouped around tables" in the arbor.

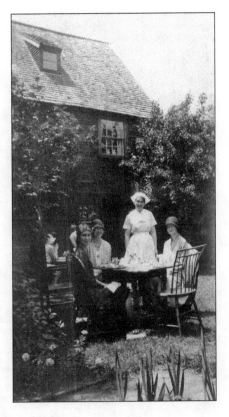

Standing beneath the grapevines of the tearoom is Sallie Ballou, dressed in the faux-Puritan attire of the tearoom waitresses. Her husband, Franklin Ballou, purchased the Dean-Sprague-Stearns House in 1930. The c. 1706 house on the corner of Essex and Flint Streets features details from celebrated woodcarver Samuel McIntire. The couple operated the home as an inn and tearoom called the East India House in the 1930s.

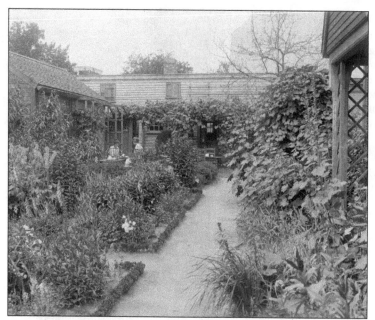

This view of the tearoom in the 1910s is seen from the summer porch across the gardens. Two women enjoy their tea under an arbor attached to the Counting House, shown in its original location. In the next decade, the Counting House would be moved closer to Turner Street to open the campus for an expansion of the gardens and the addition of the Retire Beckett House. (Courtesy Historic New England.)

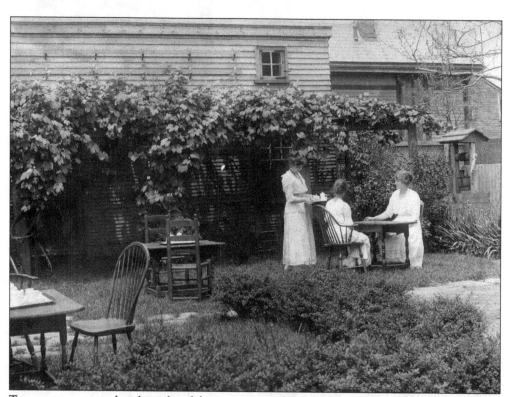

Two guests are served at the right of the tearoom on the north side of the garden. The Seaman's Bethel can be seen in the background in its new location, after it was renamed Turner Hall. At right can be seen Emmerton's reimagining of "Maule's Well" from Nathaniel Hawthorne's novel. The well features a bucket and a crank, though there was no real well beneath it.

Two people (identified as Molly and Bill) step out of the house into a snowy garden at the House of the Seven Gables in the 1920s or the 1930s. The door from which they are exiting leads to a private section of the house. Behind them is a staircase that led to the living quarters of the settlement workers. The House of the Seven Gables was and still is open year-round.

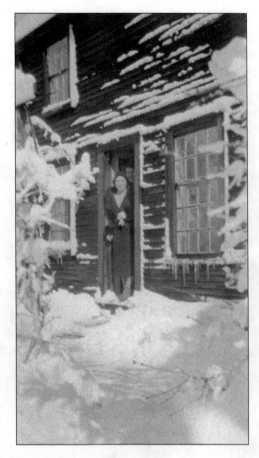

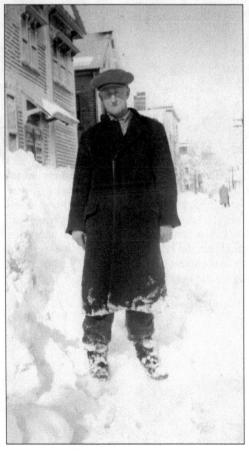

Percy Andrews, the maintenance man for Turner Hall in the 1930s and 1940s, stands on Turner Street after a snowstorm. He was born in 1888 and grew up at 43 Osgood Street on Bridge Street Neck. At the time of the 1930 census, he and his wife, Bertha, and their four children lived at 14 Mall Street, in the house where Nathaniel Hawthorne wrote *The Scarlet Letter* in 1849.

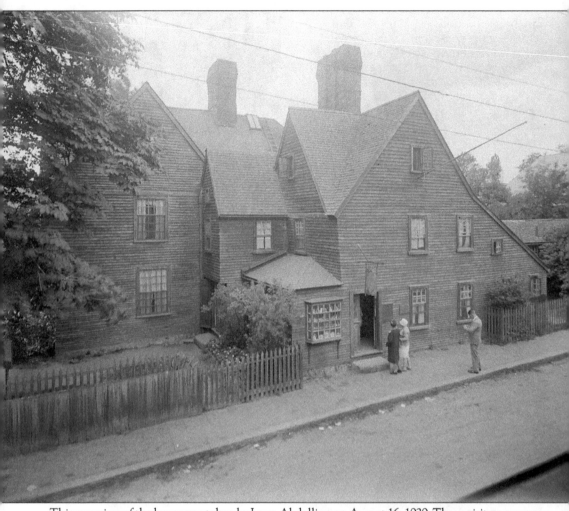

This rare view of the house was taken by Leon Abdallian on August 16, 1929. Three visitors prepare to enter the house through the cent shop door. The sidewalk has been paved with brick; Turner Street is still a dirt road. Leaflets and ticket stubs litter the side of the road. The Counting House can be seen on its intermediate location at the right of the house. At the left, the "Pyncheon Elm" has grown so tall it dwarfs the house. The window of the cent shop is stocked with souvenirs, including the House of the Seven Gables china visible on the bottom shelf. Abdallian took the photograph from a dormer window of the house across the street at Nos. 53 and 55 Turner Street. That house was built in the 1850s, likely as housing for the workers of the Stephen Whipple and Sons Copal Factory.

Seven

THE HOOPER-HATHAWAY HOUSE

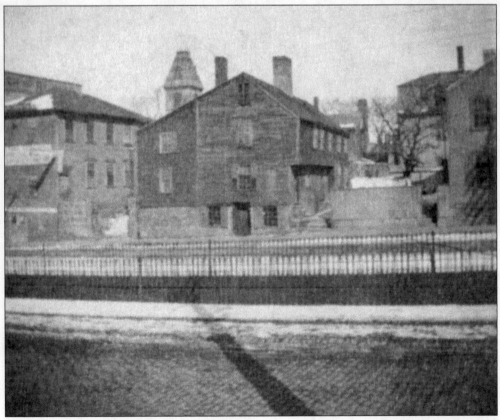

This image of the Hooper-Hathaway House at its original location on Washington Street was taken as part of a series of photographs around the turn of the 20th century. The photographer shot several notable historic houses in Salem on a snowy day, including the 1684 John Ward House before it was moved by the Essex Institute in 1910 and the 1660 Shattuck House, which was demolished in 1911.

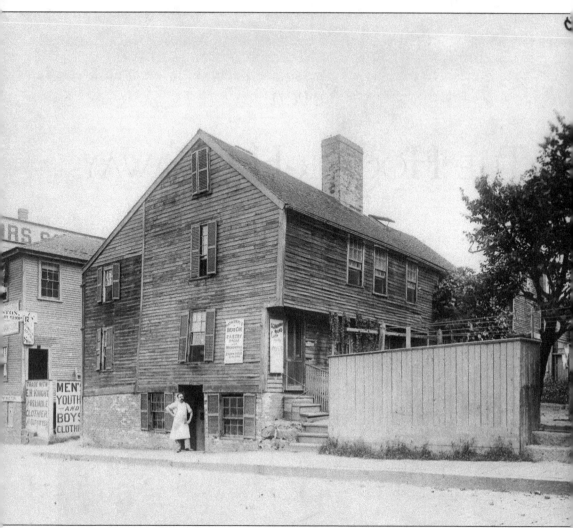

This 1890s photograph by Frank Cousins shows the Hooper-Hathway House on Washington Street. The house was built in 1682 by Benjamin Hooper, a cordwainer. The land on which the house stood was acquired from Dr. Zerubbabel Endecott, the son of early Massachusetts governor John Endecott, sparking intense antiquarian speculation about the house's frame. At the time, it was believed the frame was built with remnants of Governor Endecott's "fayre house," the first framed house in New England. Beginning in the 1860s, the Hathaway family ran a bakery in the ground floor of the house. The man standing in the doorway is likely George Hathaway. A sign above him reads, "Hathaway's Bread Cake, Pastry Store, Hot Bread & Biscuit, Every Afternoon, Brown Bread & Beans." The brick foundation and the doorway cut into the groundsill are not original to the 17th century. (Courtesy Phillips Library, Peabody Essex Museum, "21 Washington Street. Salem," Frank Cousins Collection, filed photographs, Washington Street 21, 23, 53. 43.)

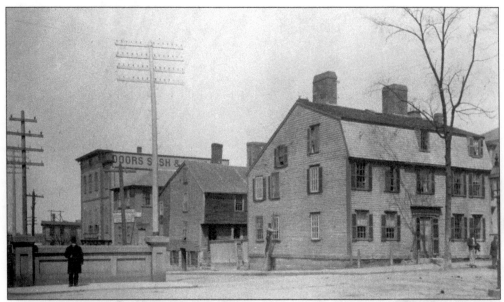

This photograph was taken on Washington Street facing northeast. The Hooper-Hathaway House can be seen at center, with the railroad tunnel for the Essex and Eastern Railroads at left. The two buildings at left housed Hardy Brothers, dealers in sash, doors, and blinds, and H.W. Thurston, a clothing repair shop, at left and right respectively. The large Georgian house at right was operated as a boardinghouse. (Courtesy Phillips Library, Peabody Essex Museum, "Federal Street 26. Salem, Mass. N.E. Corner Washington St. about 1878," 1878, filed photographs, Federal 2½–42.)

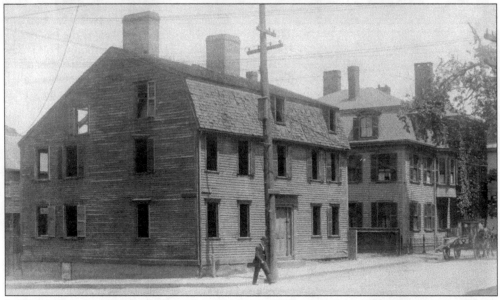

In this c. 1911 photograph, the Georgian house at 26 Federal Street can be seen partway through demolition. The windows have been removed and the planks of the roof are missing in back. In 1911, the Koen brothers purchased the house and had it demolished to build a movie theater on the site. The Hooper-Hathaway House can been at the far left shortly before it was rescued from a similar fate. (Courtesy Phillips Library, Peabody Essex Museum, "26 Federal St. Henry Rust house before 1780," filed photographs, Federal 2½–42.)

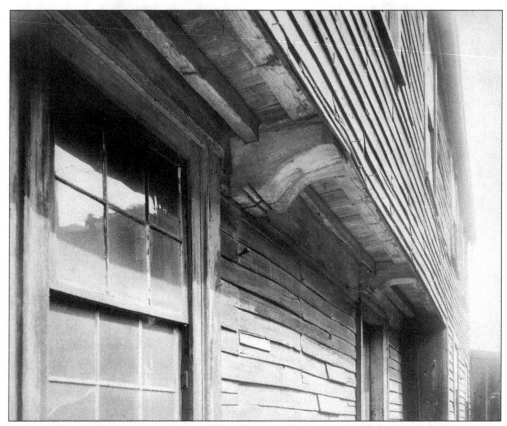

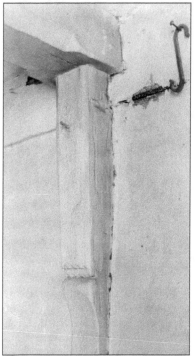

This photograph shows a detailed view of the Hooper-Hathaway House's original framed overhang. This is one of the finest surviving examples of a framed overhang. The summer beams project outside of the exterior walls and are finished with a scalloped decorative cyma curve. These decorative ends support the projecting second story. The exterior is finished with irregular hand-riven clapboards. The window at left was later replaced with a reproduction casement window. (Courtesy Phillips Library, Peabody Essex Museum, "Benj. Hooper house, 23 Washington St. Salem," Frank Cousins Collection, filed photographs, Washington Street 21, 23, 53.1413.)

This photograph shows a post in the Hooper-Hathaway House prior to restoration. It appears that the framing was never encased in later paneling, though the girts have been plastered and whitewashed. The post heads of the house have similar scalloped carvings, which are unique to this structure but which do not correspond in height. This particular post is located in the great room on the house's first floor. (Courtesy Phillips Library, Peabody Essex Museum, "54 Turner St. Corbel," filed photographs, Turner St. (1-54) House of Seven Gables.)

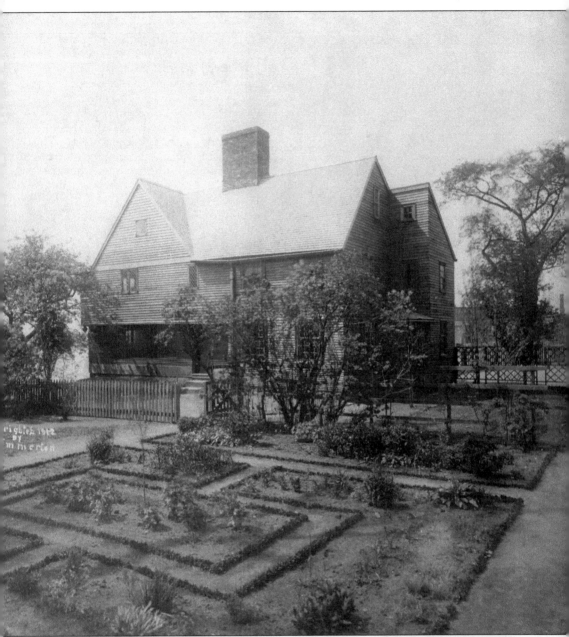

Caroline Emmerton was approached by William Sumner Appleton, the founder of the Society for the Preservation of New England Antiquities, in 1911, after he purchased the Hooper-Hathaway House to prevent its destruction. She agreed to purchase the house from him and transport it to the site. The house was divided into three sections and moved to the property of the House of the Seven Gables in July of that year. This view, from 1912, shows the house shortly after its restoration. At the left end of the framed overhang, a reproduction pendant has been added. The windows in the first-built portion of the house (at left) have been replaced with 17th-century-style casement windows. The dimensions of the diamond panes were based on an example found within the house. A facade gable has been added to the 17th-century portion of the house. The geometric garden beds were laid out in a Jacobean style.

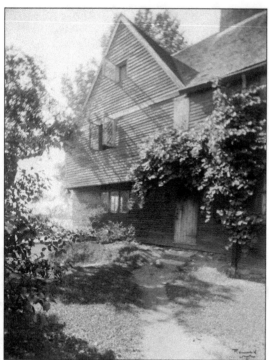

A view of the Hooper-Hathaway House from the garden shows the clapboarding is not yet painted the deep black that it is today. It retains the re-creation of a batten door added by Caroline Emmerton. The reproduction casement windows are open on the second and third floors airing out the house on a hot day. This photograph was taken by the Maynard Workshop of Waban, Massachusetts.

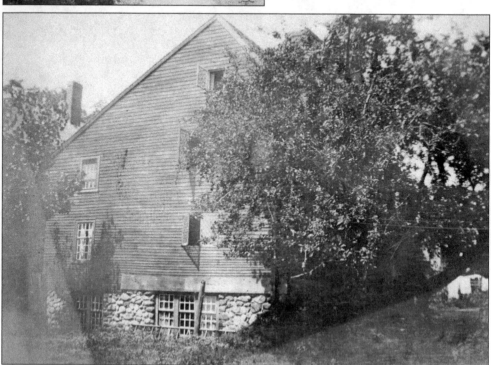

This side of the Hooper-Hathaway House once faced west to Washington Street, but it now faces south to Salem Harbor. The brick foundation has been replaced with a fieldstone foundation and a series of windows. The two-story lean-to at the back of the house has been resided to blend in with the first-built portion of the structure. (Courtesy Historic New England.)

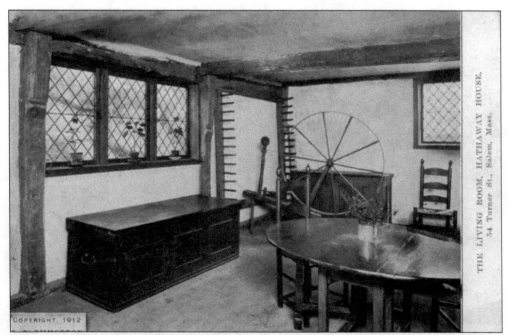

This interior view shows the early interpretation of the great room in the Hooper-Hathaway House in 1912. Furnishing the room are typical artifacts of the Colonial Revival style, including a gateleg table, a spinning wheel, and chests. The newly added three-part casement window can be seen with potted plants on the sill. The plaster has been stripped from the girts, and the paint has been removed from the frame.

This photograph of the great room has been overlaid with an illustration of a roaring fire in the hearth. It shows the shelves stocked with pewter and the tall settle at an angle to the fireplace. The shadow-molded sheathing on the inner wall was added by Caroline Emmerton during restoration.

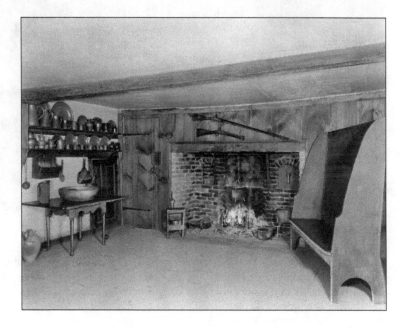

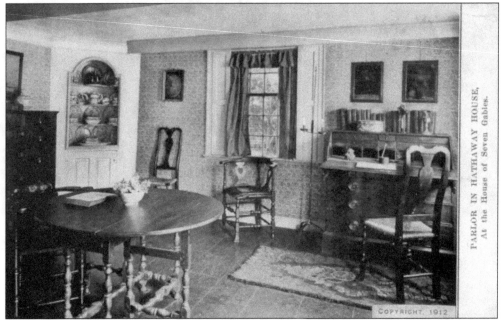

The parlor of the Hooper-Hathaway House was added to the house by 1784. Shown here in this 1912 photograph, it is decorated with a Georgian corner cupboard, crown molding, and folding shutters on the windows. The cupboard is filled with a variety of china patterns, including a strawberry pattern tea set.

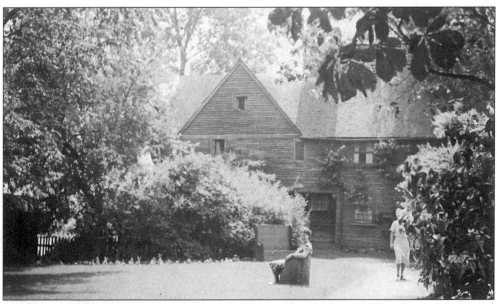

This view, looking west from the front of the House of the Seven Gables, shows the restored facade of the Hooper-Hathaway House slightly later, on its new location. Lodging was available for summer guests in the upper two stories. Guests were encouraged to sit among the flowers and trees and contemplate the picturesque view of the harbor and the old houses.

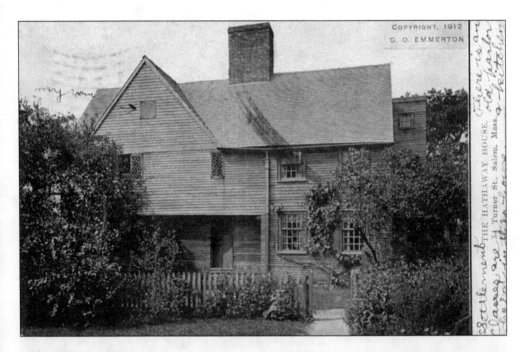

This postcard, printed from a 1912 photograph, was sent on July 12, 1915, to Helen Smith, of High Street in Ipswich, Massachusetts. The message reads, "Dear Helen, I was delighted to hear from you. Write again if you have any spare time. I am working here for the summer at the 'House of Seven Gables' as a guide, this other house is in the yard. I have a room with my aunt. It has five windows, only one shows." The front reads, "Settlement classes are held in this house, there is an old parlor & kitchen." Note in the upper left corner the arrow pointing at the attic window designating it as "my room." (Postcard from the collection of Everett Philbrook.)

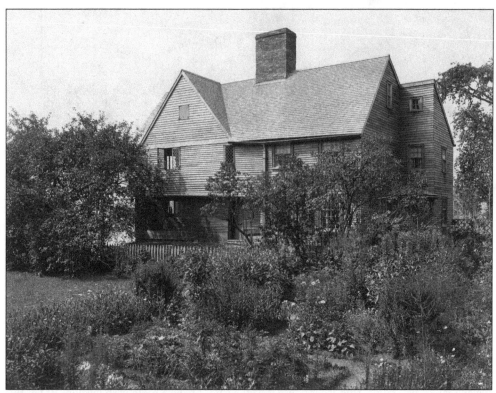

As the garden grows beside it and the house settles into its new foundation, it becomes easy to understand why visitors may think the Hooper-Hathaway House has always been a part of the property. The c. 1912 photograph above shows the spinning wheel in the great room visible through the first-floor windows, placed as it is seen in the 1912 image of that room. Prominent in this view is the Beverly jog seen on the 18th-century portion of the house at right. This type of three-story addition is found mostly in Essex County, and it is thought to have originated in the neighboring town of Beverly.

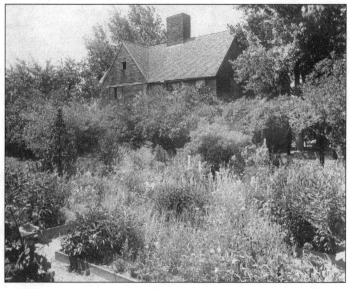

Eight

THE RETIRE BECKETT HOUSE

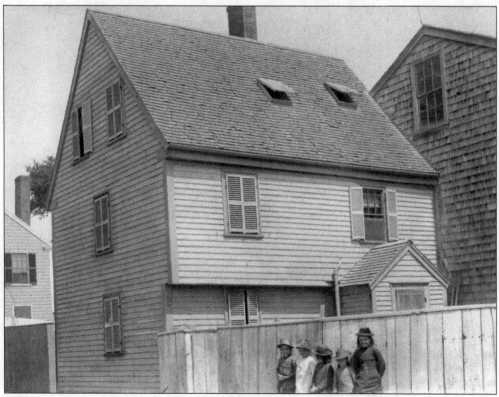

This is the earliest known photograph of the Retire Beckett House, taken in 1886. This image shows the house at its original location at 5 Beckett Street. Built in 1655, it was the home to several generations of the shipbuilding Beckett family, whose most famous member was Retire, the namesake of the house. In front of the board fence, a group of children poses for a photograph with the ancient house. (Courtesy Phillips Library, Peabody Essex Museum, "5 Beckett St. Remains of old Beckett House," 1886, filed photographs, 5036.)

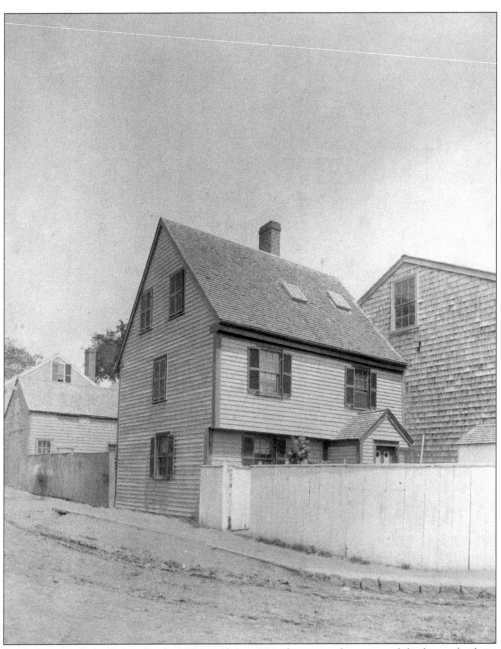

In this image of the Retire Beckett House from 1891, the original portion of the house built in 1655 is seen. Later additions to the house, which included an eastern expansion and two-story lean-to, were removed in the 19th century. Adjoining the house at right is a large barn, added in the 19th century, and the neighborhood around the house has grown since it was built. In 1916, Caroline Emmerton acquired the house and moved it to the grounds of the House of the Seven Gables in 1924 where it would join two other 17th-century Salem structures. Her intention was to open the house as an antique shop for the museum. (Courtesy Phillips Library, Peabody Essex Museum, "5 Beckett St. Retire Beckett's House," 1891, filed photographs, 18,301.)

This 19th-century view shows Beckett's Beach, where the Beckett family operated a shipyard from the 17th to the 19th centuries. Retire Beckett, the most well-known member of the family, operated it in the late 18th and early 19th centuries and was one of Salem's most prolific shipbuilders. Retire Beckett was commissioned by George Crowninshield to build a luxury vessel named *Cleopatra's Barge*, which was launched in 1816. (Courtesy Phillips Library, Peabody Essex Museum, "Beckett's Beach, Salem—Wharf scene, see Blaney St. off 85 Derby St.," filed photographs, 18,303.)

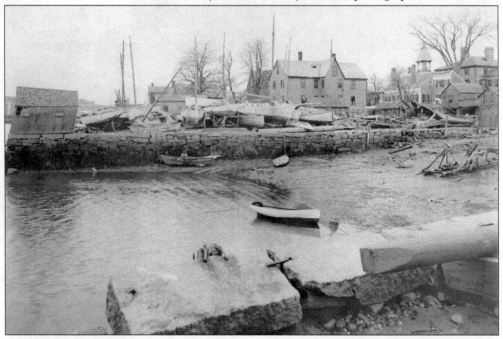

William Remon's Boatyard and Turner Street are seen from Beckett's Beach after 1914. Visible at right in the photograph is the steeple of the Seaman's Bethel, now Turner Hall, which was moved from its place near the seawall to its new location behind the House of the Seven Gables. This part of Salem's waterfront was the hub of maritime activity from its founding until the Industrial Revolution, when manufacturing took precedence. (Courtesy Phillips Library, Peabody Essex Museum, "57 Turner St. Remon's Boatyard," filed photographs, 18,303.)

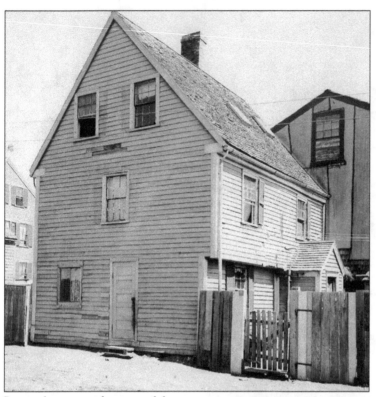

Pictured are two side views of the Retire Beckett House on its original foundation on Beckett Street before being moved to the House of the Seven Gables grounds. A door has been cut through the side of the house facing Beckett Street, which was later removed to reveal a feature that had been covered for many years—a 17th-century framed overhang. These images show the house in a period of decline, when it was neglected by previous owners and its windows were eventually boarded up. It was Caroline Emmerton who recognized the importance of this first-period structure and set about to save it. (Right, courtesy Phillips Library, Peabody Essex Museum, "Beckett St. or Ave. Old Retire Beckett House—Moved to House of Seven Gables," filed photographs, 18,299.)

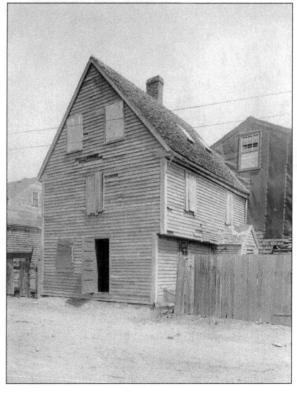

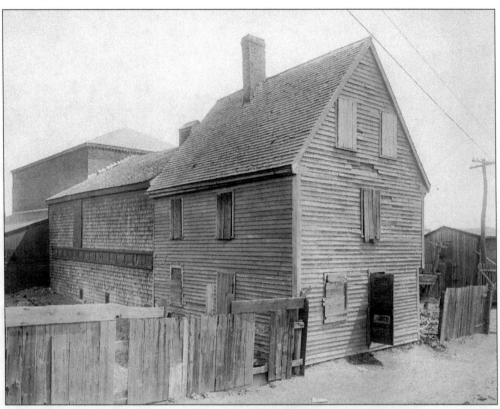

This rare rear view of the Retire Beckett House shows that it was joined with a barn and a brick building owned by the Boston & Lowell Railroad. The chimney shown in this photograph is a later replacement of what would have been a massive central chimney. It was common to remove large chimneys to add space in older houses as woodstoves became the preferred method of heating a home.

In her book *The Chronicles of Three Old Houses*, Caroline Emmerton reflects on the condition of the Retire Beckett House by saying, "In 1856 the house was sold to Michael Hayes, and from then on this long-suffering house, by then reduced to a quarter of its former size, grew shabbier and shabbier and more and more demoralized." (Courtesy Phillips Library, Peabody Essex Museum, "Beckett St. or Ave. Old Retire Beckett House—Moved to House of Seven Gables," filed photographs, 18,302.)

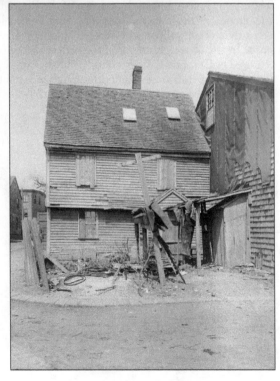

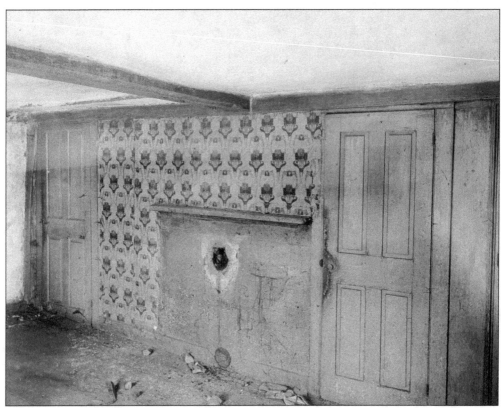

These two photographs of the interior of the Retire Beckett House, taken by L.O. Tilford, show the alterations made to the hall. The massive fireplace has been removed and the remains of ornate Victorian wallpaper cling to the plaster walls. Visible are the original summer beam and posts. In the above photograph, the wall with the outline of a prior fireplace and mantle was removed by Caroline Emmerton to create one large open room. It was not Emmerton's intention to fully restore the house as important architectural features were already missing. She chose to restore the house in a way most convenient to her.

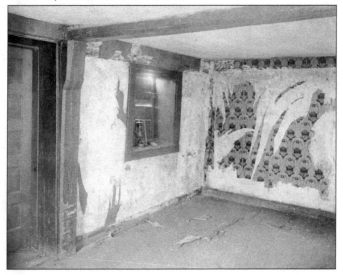

Upon entering the Retire Beckett House, one would immediately be greeted by a set of "winders" at the right that lead up to the second floor. Below these stairs is a descent to the cellar. At far right is the sentry box entrance, which was removed after the house was restored. The staircase, though old, is not the original 17th-century one.

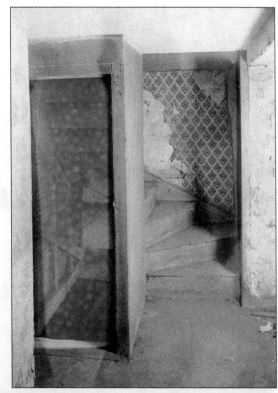

The wall seen in this photograph of the second floor of the Retire Beckett House was removed, and its raised paneling was repurposed in other parts of the house. Originally, this room would have been a hall chamber for the Beckett family. When the house was moved from Beckett Street, its original layout was reconfigured.

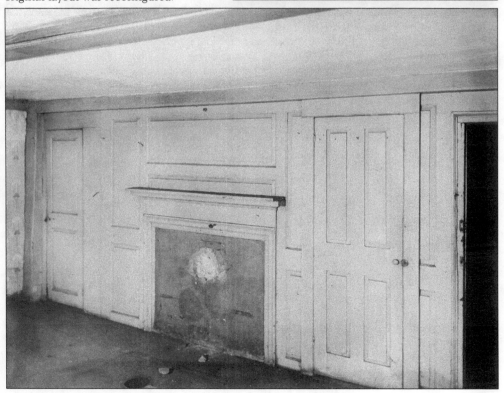

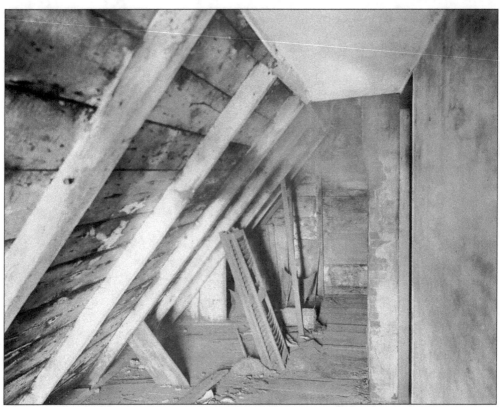

Like many first-period houses, the Retire Beckett House has a steeply pitched roof. This feature was practical in that it shed snow and water quickly from its wood-shingled roof. The jumbled framework and boards in the attic space are a result of removed later additions to the house. Attics, then known as garrets, provided additional living space. A portion of a plaster ceiling and whitewashed boards and rafters provide further evidence that this space would have been occupied at one time. Today, the attic retains much of its original architecture though the placement of the staircase has been changed and the space expanded.

A view of the cellar in the Retire Beckett House reveals the base of the 17th-century chimney, fieldstone foundation, and dirt floor. Originally, the cellar was used for storage of perishable food items. This photograph was taken by L.O. Tilford, along with other pictures of the Retire Beckett House. When the house was moved to its current location, the chimney was rebuilt in a different section of the house.

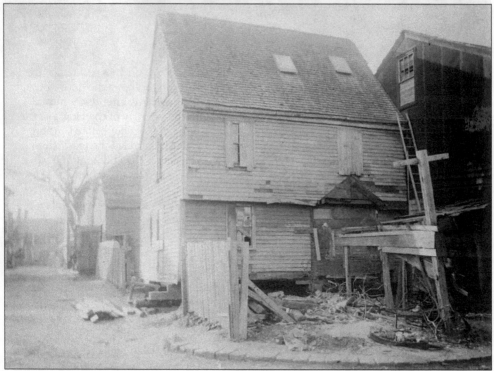

The Retire Beckett House is pictured on its original location on Beckett Street in 1924, during the process of being moved to its new location. Joseph Everett Chandler supervised the restoration and preservation of the original beams and constructed an archway and barn to complete the campus of the House of the Seven Gables. (Courtesy Phillips Library, Peabody Essex Museum, "54 Turner St. Beckett House, before being removed; now in ground of House of Seven Gables," filed photographs, Turner Street (1-54) House of Seven Gables.)

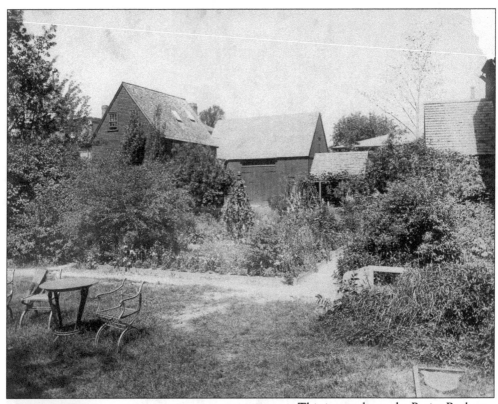

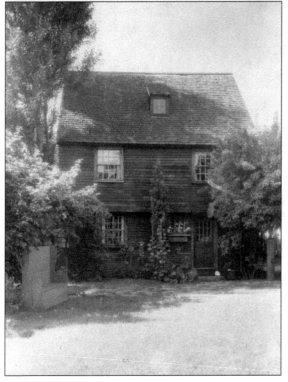

This image shows the Retire Beckett House shortly after it was moved to the property of the House of the Seven Gables but before Caroline Emmerton added the tearoom to the rear of the building. The house was joined by an archway to a barn, built on the property shortly before its arrival. At the time, it was used as an antique shop.

The front facade of the Retire Beckett House can be seen here on its new foundation. The wood-shingled roof has only been replaced a few times since it was moved to the grounds. The ship model to the left of the front door represents *Cleopatra's Barge*. Like other Colonial Revival shops, the entryway to this house is a Dutch door. On the front step is a conch shell, to enhance the maritime theme.

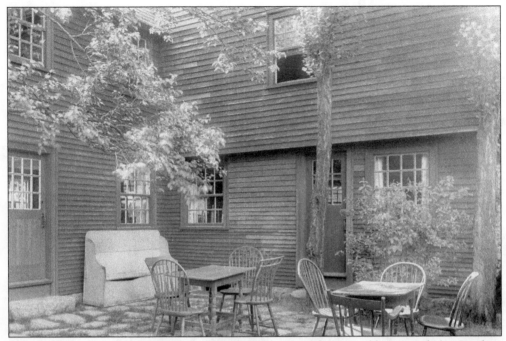

The left-hand portion of the house seen in the photograph is an addition made by Caroline Emmerton to accommodate a tearoom. The setting outside of the tearoom created an atmosphere of the past for guests to enjoy. Included were antique tavern tables and Windsor chairs for a true early–New England experience.

The interior of Caroline Emmerton's addition to the Retire Beckett House was an elegant tearoom. This room, sometimes called the Napoléon Room, was furnished with period antiques to reflect the late 18th and early 19th centuries. Caroline Emmerton wanted her visitors to experience the past in a traditional setting. Perhaps the room gets its name from the wallpaper, which depicts a gentleman in a bicorne hat, commonly associated with Napoléon Bonaparte.

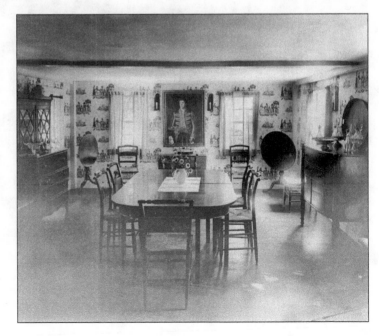

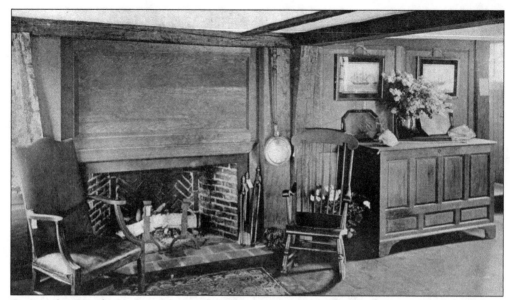

Guests who visit the House of the Seven Gables are invited to shop in the Retire Beckett House, which has been used as a store for almost a century. Being mindful of low beams and doorways has been part of the visitor experience since 1924. Shopping in a 17th-century house is a unique part of visiting the museum.

This photograph of the antique shop that occupied the hall of the Retire Beckett House shows many of the pieces available for purchase. Caroline Emmerton collected and sold a variety of genuine antiques, though many of the pieces that she collected found their way into the period rooms of the house museums on the site.

Nine

THE NATHANIEL HAWTHORNE BIRTHPLACE

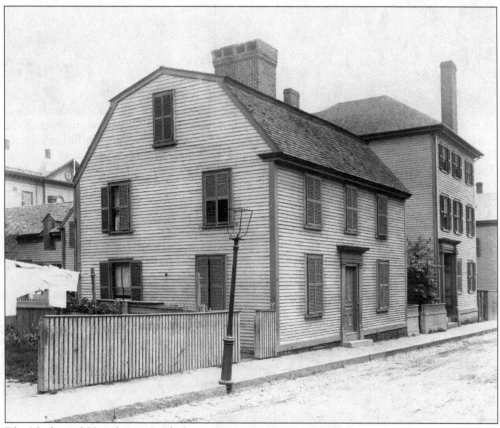

The Nathaniel Hawthorne Birthplace sits at its original location at 27 Union Street in Salem, where the author was born on July 4, 1804. The house is a typical example of a mid-18th-century Salem home, with a gambrel roof, massive central chimney, and Georgian facade. The house was purchased by Capt. Daniel Hathorne and passed through the family to the author's father, who died at sea in 1808.

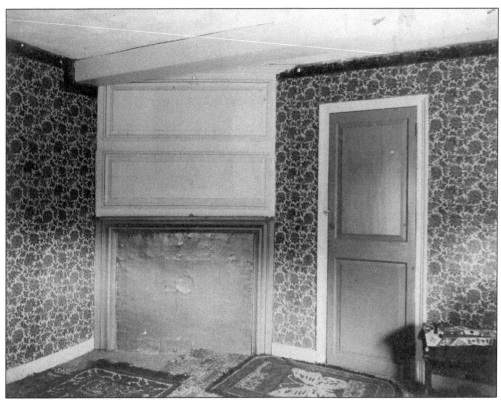

This late-19th-century photograph by Frank Cousins shows the second-floor chamber of the Nathaniel Hawthorne Birthplace, in which the author was born. After his father's death, Hawthorne's family moved into his maternal grandparents' home on Herbert Street in Salem. This image shows the room prior to restoration in 1958. It was owned at the time of the photograph by William J. White, who purchased the property in 1882.

Concerned for its welfare, antiquarians rallied around the Nathaniel Hawthorne Birthplace to transfer the building to the museum property. The house was moved on the back of a truck a half mile from 27 Union Street to its present home on Hardy Street. The back part of the house was removed and reworked when it arrived on the property. Here, it can be seen moving down Union Street early into its journey.

The Nathaniel Hawthorne Birthplace squeezes past the second-story bay window of a c. 1857 Italianate house at the end of Union Street. When the house was being moved, it attracted the attention of the neighborhood and the media. People followed the house on its journey to Hardy Street.

On its journey to its present site, the Nathaniel Hawthorne Birthplace passes another storied Salem structure, the 1727 Crowninshield-Bentley House, on its original foundation, before it was acquired by the Essex Institute. At the time, it was in use as a bakery. The businesses beside it have since been removed to accommodate a parking lot for the Hawthorne Hotel, seen in the background at center.

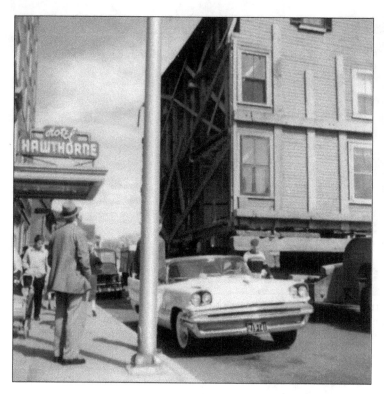

The Nathaniel Hawthorne Birthplace passes the Hawthorne Hotel, as seen here. The hotel was established in 1925 and is named for the famous author. The sill of the house is resting on a series of large timbers. A man walks in front of it to make sure that the path is clear.

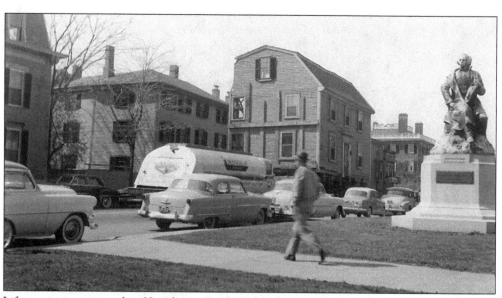

Life continues as normal on Hawthorne Boulevard as the Nathaniel Hawthorne Birthplace passes the gaze of its famed inhabitant. The statue of Hawthorne, by Bela Lyon Pratt, was dedicated in 1925. In the background, the grand house with the balustrade on the roof is the 1819 Andrew-Safford House, then owned by the Essex Institute.

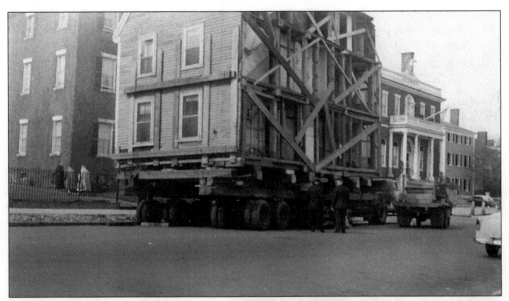

The Nathaniel Hawthorne Birthplace travels down Derby Street, past the customhouse where Hawthorne was the surveyor of the port from 1846 to 1849. It was from this experience that he received the inspiration for *The Scarlet Letter.* Visible here is the interior at the back of the house, which shows where six feet of the house was removed so it could pass through the narrow streets of Salem.

The Nathaniel Hawthorne Birthplace rounds the corner onto Hardy Street on the final leg of its voyage. A crowd is gathered to witness this historic event. At right, a worker disconnects the phone line to allow the house to pass. The boy in the foreground sits on the front step of 20 Hardy Street.

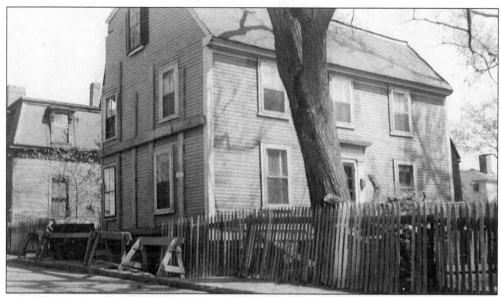

The Nathaniel Hawthorne Birthplace is shown shortly after its arrival on the campus of the House of the Seven Gables in 1958. Note the bracing on the street side of the home and the mailbox beside the front door. The house awaits restoration, a process which was overseen by Abbot Lowell Cummings, then president of the Society for the Preservation of New England Antiquities.

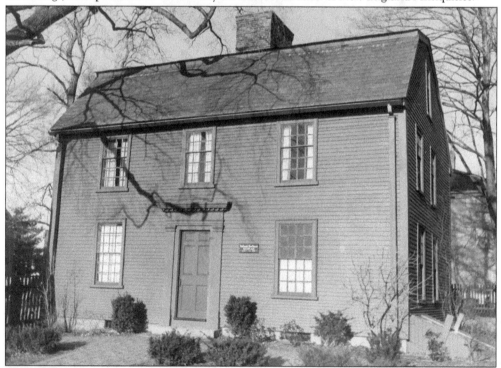

The Nathaniel Hawthorne Birthplace is seen in the summer of 1959, shortly after being moved to Hardy Street. Over the course of that year, antiques were donated and purchased from various people across the North Shore in an effort to furnish the house in an appropriate fashion. This picture was taken around the same time that visitors were able to tour the house for the first time.

Ten

AN AMERICAN ICON

In this promotional photograph, Elizabeth McIntire (in doorway), the director of the House of the Seven Gables Settlement Association, assists two tourists with a map around the year 1950. As evidenced by the merchandise in the shop window, the tourist site had attained an iconic status. Four decades after opening to the public, interest continued to grow. (Courtesy Phillips Library, Peabody Essex Museum, "54 Turner Street. House of Seven Gables," filed photographs, Turner Street (1-54) House of Seven Gables.)

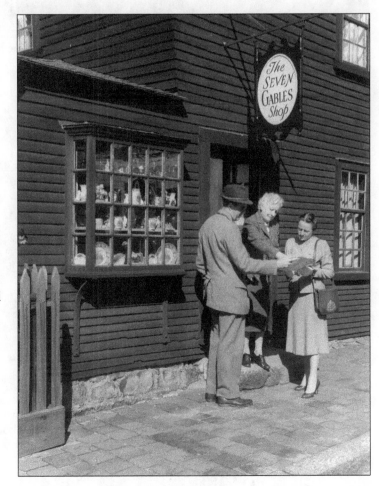

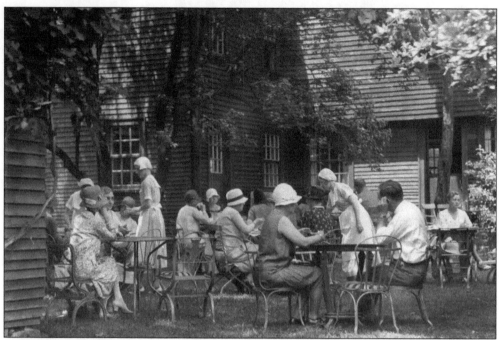

The crowded tearoom seating at the west end of the garden between the Hooper-Hathaway House (left) and the Retire Beckett House (right) is seen here in the 1920s. Though this image was taken decades ago, similar scenes can be seen today at the House of the Seven Gables. Interest in early American architecture, antiques, and history ebbs and flows, but the picturesque nature of the grounds and its buildings continue to draw visitors.

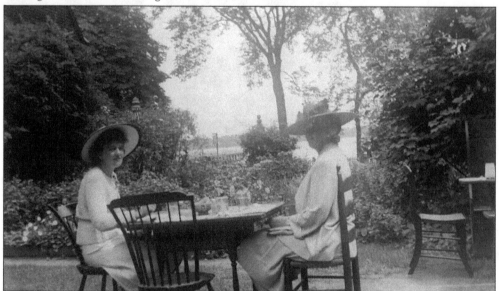

Elizabeth Haywood Upton Eaton and her mother, Lillian Arey Haywood, sit at the tearoom in 1942. The great-granddaughter and granddaughter of Henry and Elizabeth Upton returned to see their family's home a flourishing tourist site. Eaton wrote that her mother interrupted a tour of the house to explain that the letters "E.A.U." in the attic (visible on page 73) were written by her cousin Eben Albert Upton.

In this photograph, Helen Ackermann (Chapin), left, and an unidentified woman stand on the lawn of the House of the Seven Gables in the 1930s. Helen was born in 1908. Her father, Adolf Ackermann, was a drugstore owner from Indiana and the son of German immigrants, while her mother, Christine (Yeaton) Ackermann, was from New Hampshire. Helen grew up in Swampscott, in the planned Olmsted Subdivision district. In 1943, she married Gardner E. Chapin, a draftsman from Medford, Massachusetts. In 1935, Helen was only in her 20s when she began to work at the settlement house as assistant director. Elizabeth McIntire was appointed resident director of the settlement house at the same time, and the two women worked together for the organization until October 1965, when Carolyn T. Gardner took over as director of the settlement. In that time, Helen also acted as the head of arts and crafts for the settlement.

Here, Helen Chapin stands in front of the Hooper-Hathaway House around 1960. The house was part of the guided tours but still open to guests for self-guided visits. The house also provided rooms where guests could stay the night on the property. The sign features a patriotic eagle and a case for posted information.

Helen Chapin stands with her brother Carl Ackermann on the steps of the cent shop of the House of the Seven Gables in this c. 1960 photograph. Chapin lived in the House of the Seven Gables until 1964. She played an integral role in the settlement house for over three decades.

A young Racket Shreve pulls at the Dutch door of the Hooper-Hathaway House in this photograph by Julian Carpenter from April 1950. His brother Benjamin Shreve looks on. Racket, who would later become a notable Salem artist, donated this photograph and the one below to the House of the Seven Gables. The sign next to the door indicates that rooms are available for guests.

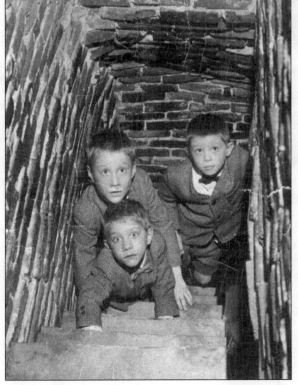

Three boys climb the secret staircase, one of the memorable aspects of the tour of the House of the Seven Gables, in April 1950. Though Caroline Emmerton had the staircase built during the restoration in 1909 and 1910, generations of tour guides told visitors that the staircase traced back to the Salem Witch Trials or the Underground Railroad. At front is Racket Shreve, behind him are Benjamin Shreve (left) and Robin Potter.

123

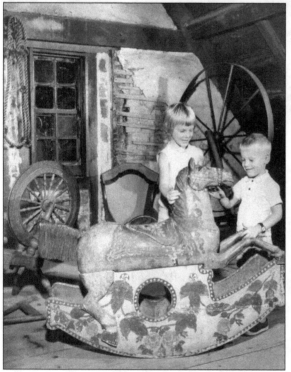

This promotional photograph for the house's tercentenary in 1968 shows the kitchen in the House of the Seven Gables, built in 1668. A family views the kitchen hearth, which still looks much as it did decades earlier when it was decorated by Caroline Emmerton. The methods of conveying the house's story have changed over time, but the fabric of the house remains largely unchanged. (*Salem News* photograph by David Matt.)

This is another in the series of photographs from the house's tercentenary in 1968. Two young children admire a 19th-century rocking horse in the attic of the House of the Seven Gables. Compare this view with the one on page 84, which was taken in the early 1920s. The static antiques create a through-line across time uniting generations. (*Salem News* photograph by David Matt.)

This view shows the great chamber of the House of the Seven Gables in 1968. The bedstead in the photograph once belonged to the Hawthorne family. At the foot of the bed is a pull-out trundle, which was used for additional sleeping accommodations for children and could be hidden away to save space. (*Salem News* photograph by David Matt.)

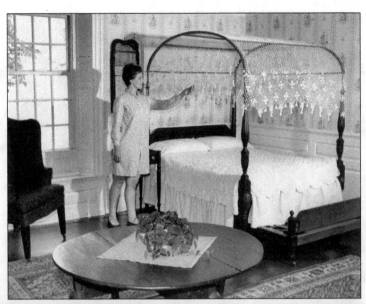

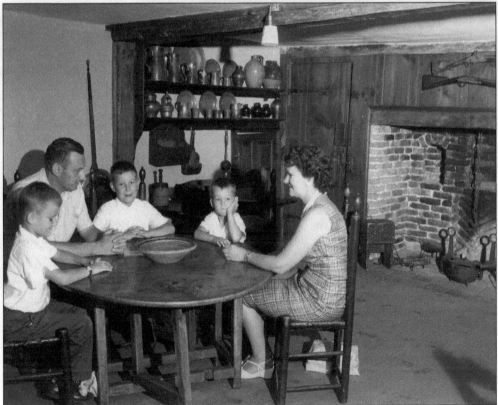

The family in this photograph gathers around the table in the great room of the Hooper-Hathaway House. Families have long been a part of the visitation and the community around the House of the Seven Gables. The room in which they sit is still used for educational programs. The standards of interpretation have evolved over the years to a clearer understanding of the site's past and its relationship to Salem.

Three women enter the House of the Seven Gables shop from Turner Street around 1960. Around that time, the house received about 50,000 visitors a year. By 1966, that number swelled to over 87,000. The cent shop on Turner Street was the main entrance to the house until the visitor center was built to accommodate growing visitation. In 1942, Caroline Emmerton passed away, but her spirit and ingenuity persisted. She is fondly remembered, and many have since taken up her cause. Generations of visitors have passed through the rooms, and generations of caretakers have maintained the structure and its property. Tour guides through the ages have told the story of this hallowed house and its inhabitants to countless crowds of curious visitors. Generations of new immigrants and members of the Salem community benefitted from the settlement house and its many services. Long into the future, people will enjoy this unique resource. The house itself perseveres, long since Nathaniel Hawthorne passed its doorstep and hundreds of years since John Turner laid such a solid foundation in view of Salem Harbor.

ABOUT THE ORGANIZATION

The House of the Seven Gables Settlement Association was founded in 1908 by Salem philanthropist and preservationist Caroline O. Emmerton. Her mission to enrich the community by providing social services and programs for newly arrived immigrants and by preserving the architectural and historic treasures of Salem is continued today. For more than a century, the House of the Seven Gables Settlement Association has helped generations of families settle into a new country and has welcomed millions of guests from all over the world to visit some of the most important early American houses.

Today, the House of the Seven Gables Settlement Association serves the modern immigrant communities of Salem through literacy, citizenship, college preparation, and cultural programming. Even though the focus of the work has expanded beyond the immediate neighborhood, the settlement mission remains the same: to provide educational and enrichment opportunities for the community.

As Caroline Emmerton wrote, "If, as is generally conceded, the settlements do the best Americanization work, should not this settlement excel whose home is the ancient House of Seven Gables, the foundations of which were laid by the first immigrants who came here long ago, strangers in a strange land?"

Visit us at
arcadiapublishing.com